IMAGES
of America

GREEN VALLEY
ARIZONA

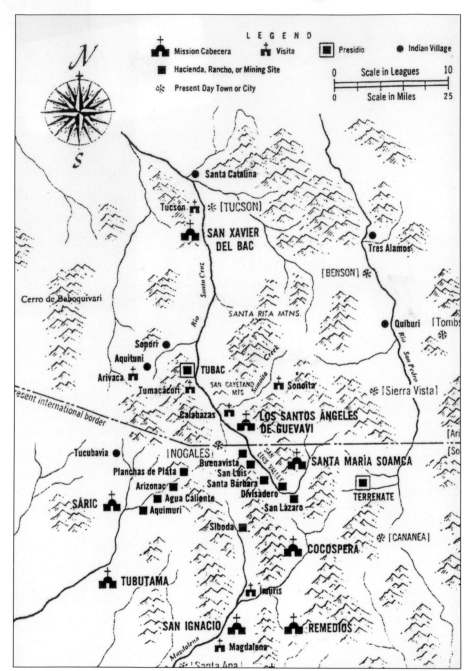

WHERE IS GREEN VALLEY? This map of Pimería Alta (Upper Pima Indian country) shows the northern Spanish Mission frontier from 1691 to 1767. The Pima Indians are probable ancestors of the present-day Tohono O'odham Indians in the Green Valley area. The Santa Cruz River flows north between the Santa Rita Mountains to the east, and the Sierrita Mountains to the west. Guevavi and Tumacacori Missions are south of Green Valley, and San Xavier del Bac Mission is north. Spanish warriors, settlers and Jesuit priests marched through, left their language and religion, and changed the livelihood of the Indians. All this occurred when the area was New Spain, almost three hundred years before Green Valley existed. Courtesy Tubac Historical Society.

2

IMAGES
of America

GREEN VALLEY
ARIZONA

Philip Goorian

ARCADIA
PUBLISHING

Published by Arcadia Publishing
Charleston, South Carolina

Printed in the United States of America

Library of Congress Catalog Card Number: 2002107713

For all general information contact Arcadia Publishing at:
Telephone 843-853-2070
Fax 843-853-0044
E-mail sales@arcadiapublishing.com
For customer service and orders:
Toll-Free 1-888-313-2665

Visit us on the Internet at www.arcadiapublishing.com

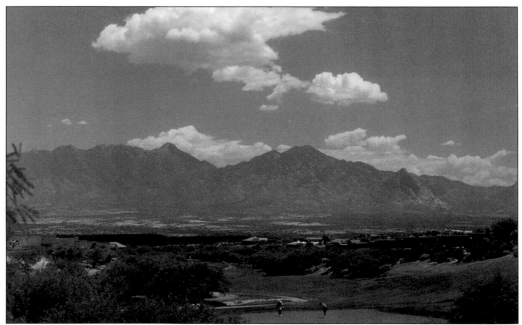

POSTCARD. A spectacular view from Green Valley of the Santa Rita Mountains and the Santa Cruz River Valley. This pre-1966 photograph precedes the Smithsonian-Whipple Astrophysical Observatory, which is clearly visible today from Green Valley atop Mount Hopkins. This peak, named after Gilbert W. Hopkins, is 8,585 feet high in clear air. Mt. Wrightson, at the top of the Santa Rita chain reaches 9,453 feet. This summit is named after William Wrightson, once manager of the Santa Rita mines. Photo credit Jerry Marrion, courtesy Green Valley Chamber of Commerce.

CONTENTS

ACKNOWLEDGMENTS

My appreciation to the many organizations and individuals who supplied photographs and information so useful for *Images of America: Green Valley, Arizona*. These include the Arizona Historical Society; Kathy Engel, *Green Valley News & Sun*; Mary Bingham, Tubac Historical Society; Conrad Joyner, Green Valley Library and Friends of the Green Valley Library; Jim DiGiacomo, Green Valley Chamber of Commerce; Dr. Richard Grabowski; and the *Sahuarita Times*.

Others who gave or loaned photographs include Lynn Harris, historian; McGee Ranch Settlement; Deezy Manning-Catron; Canoa Ranch; Helene Rogers; Green Valley Chamber of Commerce; Mission San Xavier del Bac Museum; Titan Missile Museum; Tumacácori Mission National Monument; Jean Fuer, eighth-grade teacher, Continental School Oral History Project; Mercy Teso and Mrs. Barbara Bennett, Sahuarita; Maria Esparza, Continental; Charlotte McManus, Farmers Investment Company; Michael Kalt III; Gael Chilson; Herbert Wisdom; Stan Raney; radio station KGVY for their interview; Tubac State Historic Park; and Tumacácori Mission National Monument.

Green Valley and Sahuarita supporting merchants include Ace Hardware; Walter L. Henderson, Attorney at Law; Aracely's Interiors; Arizona Family Restaurant of Tucson; Body Start Health & Fitness; Jim Click Ford Lincoln Mercury; Green Valley Cooling and Heating; Green Valley Recreation; Hickey Automotive; Kachina Telecommunications; Richard L. Kaegy; Mailboxes Etc.; A.B. McRae; D.D.S.; Meredith's Hallmark Shop; Timothy A. Olcott, Attorney at Law; Old Chicago Deli; and SEDCO Sales.

Also, the Antique Automobile Club of America, Tucson Chapter, and the Santa Cruz Valley Car Nuts.

Belated thanks to those Native Americans, Spanish and American pioneers, miners, ranchers, settlers, and retirees who left their memories, their relics, and their history.

Finally, applause to my devoted wife, Teresa A. Goorian, who helped so much in photo compilation, word choice, and of course, the most necessary of ingredients, encouragement and perseverance.

INTRODUCTION

A Brief History of Green Valley and Surroundings

Green Valley, the Land of New Beginnings, is a retirement, trade, and cultural center nestled 3,000 feet between mountains. The Santa Rita Mountains soar to the east; the Sierritas loom west. Green Valley, 20 miles south of Tucson and 43 miles north of Nogales, Arizona/Mexico, has been home to many peoples: Hohokam, Pima, and Tohono O'odham Indians, Spanish warriors, ranchers, Jesuit and Franciscan missionaries, desperados and prospectors, Mexicans and Anglo-Americans. The flags of Spain and Mexico, the United States of America, the Confederacy (briefly), and the State of Arizona have flown here. The first settler was a long-vanished Hohokam Indian; the latest a newly arriving snowbird who steps out of his car at a friend's home or a real estate office, looks around, and likes what he sees.

Modern Green Valley history began in 1953 with an inspiration—a highway sign on Interstate-19 that read "Live Now—Not Sometime—in an Established Community." That early dream became a reality when Chicago developer Donald Maxon and his brother/architect/construction manager Norman used a 1959 amendment to the Federal Housing Administration to build subsidized housing for the elderly. The University of Arizona Foundation and the New York State Teachers Retirement Fund sponsored the Maxon's non-profit University Retirement Corporation.

In 1964, the brothers purchased 2,900 acres from the Farmers Investment Company (FICO), once Canoa Ranch, for residential development. They visited Alamos, Sonora, to study and photograph the late 18th-century Spanish Colonial styles. They liked the arched colonnades, wrought iron screens and red roofs. Green Valley was under way. This land of mountains, deserts, and stately saguaro, tiny towns and old ranches, extinct and extant mines, and ghost towns, became a name on the Arizona map. The first apartments, low-rental units, were finished in 1964 on La Cañada Drive, followed by Fairways townhouses with nine holes of golf, The Foothills, and Green Valley Acres. With partner Hunkin Conkey Construction Company of Cleveland, the Maxon's completed 15 apartments per day. The frantic pace continued a year until they completed more than 1,000 units, with recreation, shopping, and medical centers.

More homes, apartments, shopping centers, and golf courses followed but occupancy lagged. By 1966, Maxon Construction Company was overbuilt and appeared headed for bankruptcy. FHA foreclosed on 1,150 rental apartment units, a shopping center, swimming pools, and numerous recreational and medical facilities, and reorganized Maxon Construction as the Green Valley Development Company. When construction resumed in 1967 and 1968, the community assumed its present shape. Development has been constant since.

In 1965, approximately 500 pioneering retirees from across the United States and Canada called Green Valley home. In 2000, the census counted 17,283 permanent residents, an ever-expanding population that doubles in the balmy winter months. The sun shines 300 days each year, and 10 to 11 inches of rain falls, mostly during the summer monsoons. Up in the Santa Ritas, snow lingers on the peaks for days at a time. Long-term maximum summer temperatures average 101 degrees, but dip below freezing before sunrise in January. A 68-degree July night is pleasant after a hot day.

Residents and winter visitors alike enjoy the large Joyner-Green Valley Library, bowling alley, softball fields, heated swimming pools, spas and saunas, shuffleboard, tennis courts, and golf courses galore. There are 21 churches and a Jewish temple, three large hotels and motels, and 600 named avenues and avenidas, streets and calles, places, paseos, and placitas. Green Valley is the only place in the United States with a deactivated Titan II Intercontinental Ballistic Missile, designated a National Historic Landmark on October 14, 1994.

In 1997, Choice Magazine rated Green Valley one of the top 20 retirement towns in the United States. In 1998, New Choices magazine nominated Green Valley "the highest value for your retirement dollar," and among the 20 best of the 2,000 retirement communities surveyed. In 1999, Smithsonian Magazine declared, "Green Valley is a well-established bedroom community located between Tucson and Nogales in prime javelina country."

Green Valley has a rich Western past. It has been known as Pimaría Alta, New Spain, San Ignacio de la Canoa land grant, New Mexico Territory, part of the Gadsden Purchase, and the Territory and the State of Arizona. From 500 B.C.E. to 1450 A.D., Hohokam Indians, "people all used up" to the Pimans, lived here. The Tohono O'odham, possibly their lineal descendants, followed a timeless and self-sufficient cycle of gathering wild desert plants, irrigating crops, and hunting. Many tribal members live on the reservation unit at Mission San Xavier del Bac, a few minutes drive from Green Valley.

Although the community is new, its history is not. Green Valley is the happy product of the past and the present.

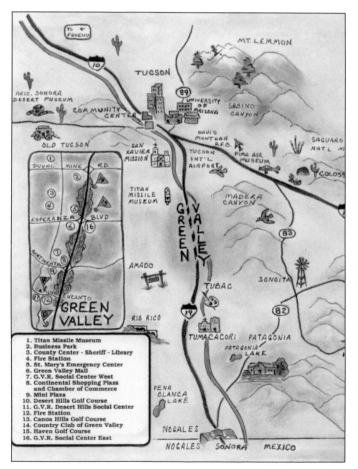

MAP OF GREEN VALLEY. This whimsical map drawn for the Green Valley Chamber of Commerce shows the area 30 years ago. The size of unincorporated Green Valley is somewhat exaggerated. Many locations and points of interest from the earliest days—the Missions, Nogales, Tucson, the river, and the mountains—are ancient; others, as the Titan Missile Museum and Green Valley itself, date back to 1963. Courtesy Green Valley Chamber of Commerce.

1. Titan Missile Museum
2. Business Park
3. County Center - Sheriff - Library
4. Fire Station
5. St. Mary's Emergency Center
6. Green Valley Mall
7. G.V.R. Social Center West
8. Continental Shopping Plaza and Chamber of Commerce
9. Mini Plaza
10. Desert Hills Golf Course
11. G.V.R. Desert Hills Social Center
12. Fire Station
13. Canoa Hills Golf Course
14. Country Club of Green Valley
15. Haven Golf Course
16. G.V.R. Social Center East

One

GREEN VALLEY

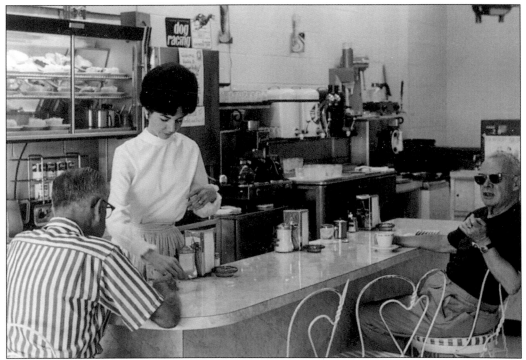

LA ESQUINITA. The first resident of Green Valley was Leo J. Hohler, known to all as "Tebone." In 1964 this early businessman opened La Esquinita (the little corner), an ice-cream parlor and snack shop. It became a popular coffee shop, then a restaurant. The parlor featured sodas, sundaes, and banana splits. The backs of the "ice-cream chairs" were heart-shaped, the tables pink Formica, and Tebone wore pink pants. A television set with rabbit ears completed the scene of a mid-60s ice-cream parlor anywhere in mid-century America. A waitress served the counter trade while Tebone waited on tables and took orders. The counter was state-of-the-art, offering coffee, soda, and pastry, with lots of space for businessmen, tourists, day workers, new natives and old residents alike to mingle. Jell-O salad with cottage cheese was 25¢ and a double order of Aunt Emmy's cookies went for 15¢. A chicken salad sandwich was also available for 50¢. Courtesy Conrad Joyner, Green Valley Library.

TEBONE. Tebone, a town personality, moved from Ohio in 1963. He became Green Valley's first resident, even before streets were installed. This man of many parts acted in early skits and plays, portraying a Rough Rider, sharpshooter, grizzled man about town, and cracker barrel philosopher. When this Midwesterner and transplanted Arizonian donned his costume, makeup, and persona, the Old West came alive. Photo credit Tebone, Courtesy Conrad Joyner-Green Valley Library.

PIONEERS. Old settlers gather at the Founders, or Pioneers Day, celebration at Valley National Bank. From left to right, are: (standing) Helene Rogers, Kay Maxon, and her husband Norman, with hat; (seated) Don Maxon and his wife Luanne. National Bank is now Bank One. Don Maxon still lives in Tucson; Norman in Safford, Arizona. Helene Rogers remains active in real estate in Green Valley. Courtesy Helene Rogers.

MAXONS. The Maxon brothers, Don and Norman, came to the area they later named Green Valley, looked around, and decided it was a good place for a retirement center. They studied the colonial architecture of Alamos, 250 miles south in Sonora, purchased 2,900 acres from the Farmers Investment Company for residential construction, and built subsidized housing for the elderly under the Federal Housing Administration. By 1963, Green Valley was under way. Don Maxon described how Green Valley was named: "In July of 1961, one of our vice presidents, Charlie French, and his wife, Jeanette, together with my wife, Mary, and myself were driving to Phoenix. On the way we discussed the selection of a suitable name. Charlie described the beautiful site and in so doing mentioned that it was a beautiful green valley. I think it struck us all about the same time. On the way back to Tucson, Mary said, 'Why not call it Tucson Green Valley?' So before we arrived back in Tucson, a new town, to become one of the most beautiful suburbs in America, had been named. Later the prefix 'Tucson' was dropped." Courtesy Conrad Joyner-Green Valley Library.

CHARLES "CHUCK" RICHARDSON. Richardson was an early pioneer and businessman in Green Valley. He was vice-president, number three man in the Maxon Construction Company, and chairman of the Community Council, which became the Green Valley Community Coordinating Council, Inc. (GVCCC) in 1969. Green Valley is not incorporated. GVCCC serves as a local volunteer government in place of an established government, and provides liaison with all branches of county government. Courtesy Conrad Joyner, Green Valley Library.

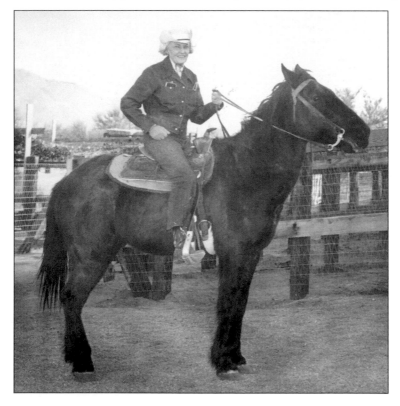

RIDING. Mrs. Francis Sampe Holmlund in cowgirl regalia sits on her mare at the Green Valley Riding Club. Horses have been part of Green Valley life, for work and play, since the beginning. Mrs. Holmlund donated $1 million to Assisted Living at La Posada. The wooden posts of the corral have been replaced by white plastic in the Equestrian Center at Canoa Ranch. (Snow-covered Mt. Wrightson looms in the eastern distance.) Courtesy Conrad Joyner-Green Valley Library.

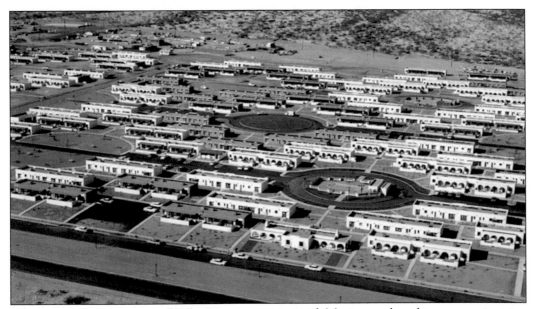

HOMES. Pictured is a portion of Villas West apartments, with Mexican-style architecture, swimming pool, and pedestrian and traffic circles. These low-rent units on La Cañada Drive, looking east to Madera Canyon, were finished in 1964. Fairways followed with homes on nine holes of golf, then the Foothills and Green Valley Acres. A year later a small community of 1,000 units and associated facilities was open for occupancy. Courtesy Conrad Joyner, Green Valley Library.

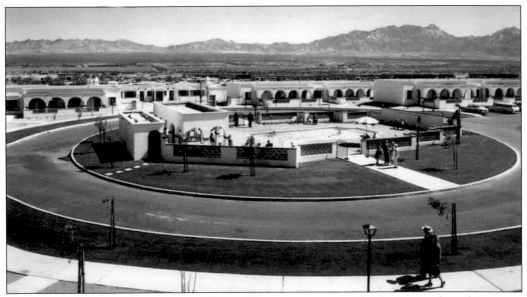

APARTMENTS. Pictured is a portion of Villas West apartments, with Mexican-style architecture, swimming pool, and pedestrian and traffic circles. These low-rent units on La Cañada Drive, looking east to Madera Canyon, were finished in 1964. Fairways townhouses followed with nine holes of golf, next. The Foothills and Green Valley Acres. A year later a small community of 1,000 units and associated facilities was open for occupancy. Courtesy Conrad Joyner-Green Valley Library.

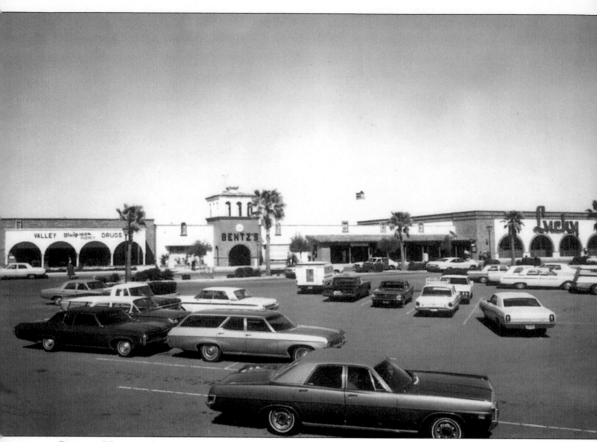

GREEN VALLEY MALL, C. 1970. The mall, now greatly expanded, was the first shopping complex. An early-day sign announced "40 Stores to Serve You." Valley Drugs is on the left; Benz's and Lucky Market, a California chain, are center and right. None exist today. Goodman's grocery opened in 1964 and Ace Hardware has occupied the site since 1978. Green Valley retirees almost kept up with the model years. Chevrolets from 1960 to 1965, a Ford Thunderbird, a 1967–1968 Falcon, 1968 Ford pickup, 1964–1965 Mustang, and an International Travelall are parked. Spaces closest to shops were rare during winter working hours. A few palm trees complete the scene of an early shopping center in southern Arizona. Helene Rogers, a realtor who arrived in Green Valley in December 1963, said her first impression was of "bulldozers all over the place." Courtesy Conrad Joyner-Green Valley Library.

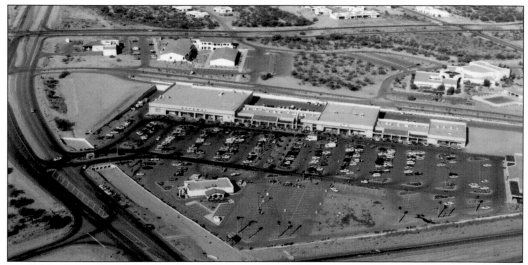

CONTINENTAL SHOPPING PLAZA. Safeway is the large pre-1980 building on the left, off the corner of I-19 and Continental. Safeway is still there and expanding. West Center of Green Valley Recreation is off to the right. State Savings and Loan building stands alone on the left, on a crowded site occupied by McDonalds. Business, then and now, is dynamic. Safeway is building another outlet, Green Valley Recreation centers expanded, but State Savings is gone. The Plaza is now five blocks long. Courtesy Green Valley Chamber of Commerce.

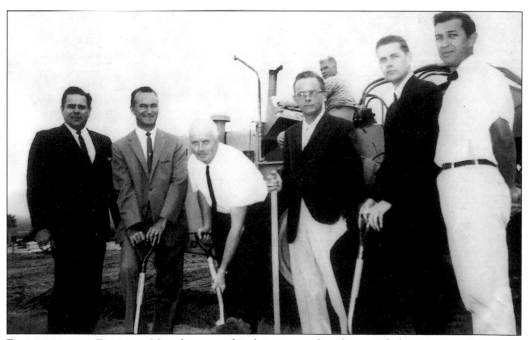

BUILDING THE FUTURE. New housing developments, churches, and shopping malls were a common feature in the booming Green Valley of the late 1960s. Builders dig deep to get Pima Savings Bank off to a good start. Norman Maxon looks on from the left; Jack White is second on the left; Don Maxon wields the spade; and architect Jim Smith is fourth from left. This group is making their symbolic penetration of the earth in a groundbreaking ceremony. A bulldozer waits behind for more serious digging. Courtesy Conrad Joyner-Green Valley Library.

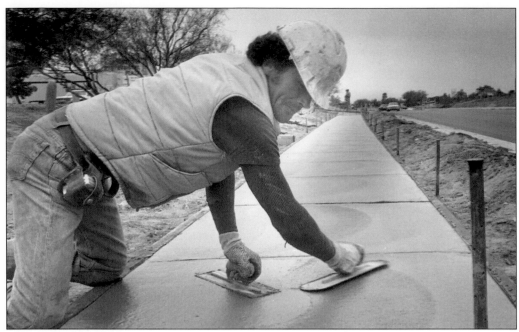

BUILDING GREEN VALLEY. Building a new town in the desert takes lots of work by many people. Here a Hispanic worker lays the final touches to pavement, smoothing the new concrete with floaters in both hands. Behind him are residential buildings, and in front, the Sonoran Desert. Courtesy *Green Valley News & Sun*.

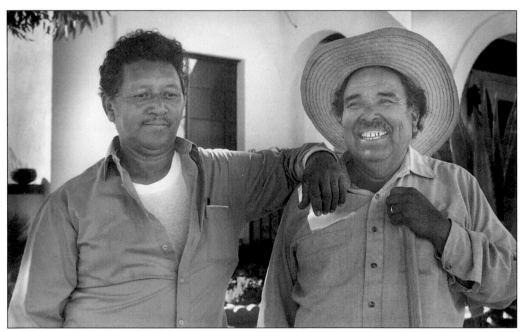

AMIGOS. Two good friends, dressed for hard construction work, stop for a break and a laugh. The Spanish language was used in the Santa Cruz River Valley long before English, and is still common in the shops and on the streets. Many families use it as a home language. Some workers have settled into Green Valley as a permanent home. Courtesy *Green Valley News & Sun*.

BRICKS AND MORTAR. Setting bricks in place takes a good eye and lots of cooperation. As the early town mushroomed in the late 1960s and '70s, workers came from many places seeking employment. Trowels in hand, they made the buildings rise, brick by brick. Courtesy *Green Valley News & Sun.*

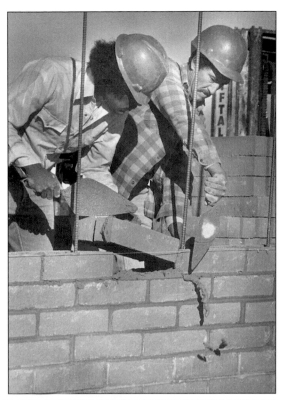

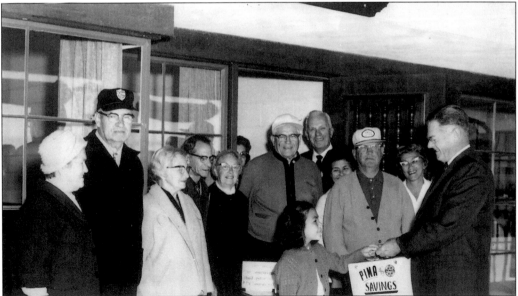

PIMA SAVINGS BANK. A crowd gathers in 1973 at Pima Savings, to celebrate in-town banking in the Green Valley Mall. Pictured right front are R. Johnson and George Payne, manager. Payne said, "I opened the door and a mess of dead crickets was all over the place! A little paneling, carpets, and drapes transformed the desolate scene into a warm, friendly atmosphere. The view from the front window east to the Santa Ritas was spectacular." Pima Savings is no longer there. Courtesy *Green Valley News & Sun.*

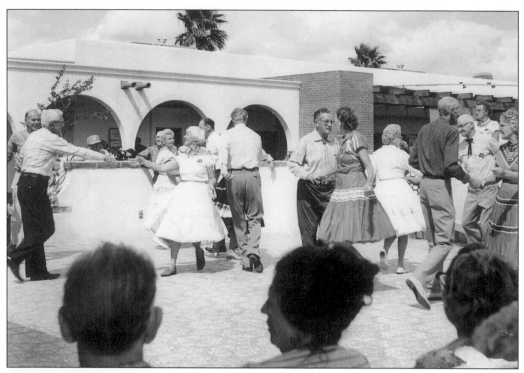

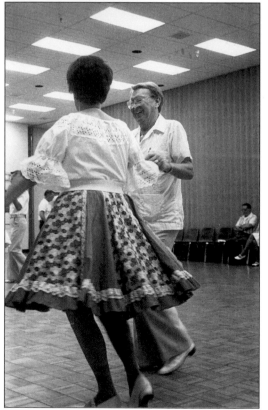

THE DANCE. The Green Valley square dance team showed the way at the grand opening of Pima Savings and Loan Association in 1967, on the patio of East Social Center. The blazing sun did not detract from the fun as two squares of dancers made the opening official. The local chapter uses the standard calls—basic, mainstream, and plus—that are recognizable all over the square dancing world. Charles Kuralt, CBS, visited the Green Valley Squares for his program "On the Road." Courtesy *Green Valley News & Sun.* (Cover photo)

ROUND DANCING. Ken and Carol Jones, round dancers in the 1970s, kick up their heels in Green Valley Recreation Desert Hills Social Center. Pictured second on the right, watching the demonstration, is Ken Dye; just right of Ken is Benedict Barton. Square and round dancing started in Green Valley in 1965 and continues, along with Los Bailadores Dance Club, Ballroom Dancers, International Folk Dances, Line Dancers, Roun-de-lay Dance Club and the Green Valley Tappers. Courtesy *Green Valley News & Sun.*

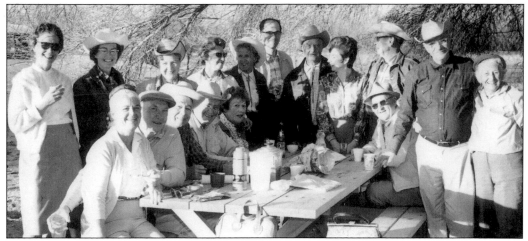

PICNIC. Green Valley Riders Club goes to Madera Canyon to seek fun and cooler temperatures. Shown seated, left to right, are Sallie Christopher, Verne Catlin, Ruth Harlan, Fran Reed, and Pat Catlin, among others. The Club organized a 30-minute automobile drive through Continental along White House Canyon Road to relax in a designated picnic area. Then it was home again, in the early 1970s. Courtesy Conrad Joyner-Green Valley Library.

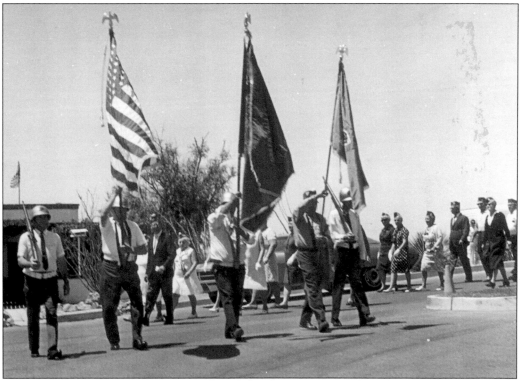

PATRIOTISM. The American Legion presents the flag at the opening of the second post office in 1974. Uniformed color guards from the Legion and Veterans of Foreign Wars perform memorial ceremonies and honor the flag at the Green Valley Mortuary. The burnished sun shines brightly in the early morning, as veterans proudly remember old times in the Armed Forces. Courtesy Conrad Joyner-Green Valley Library.

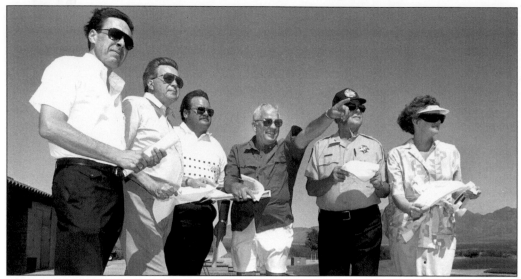

FOURTH OF JULY. Stan Raney, president of Green Valley Chamber of Commerce; Frank Newell, publisher, *Green Valley News & Sun*; Kevin Lewis, San Ignacio Golf Estates; Charles "Chuck" Shipman, Green Valley Community Coordinating Council; Ken Bichel, Sheriff's Auxiliary Volunteers; and Cathy Vander Linden, Green Valley Recreation, plan the forthcoming Fourth of July celebration. The annual ceremony moved from San Ignacio Golf Estates to Quail Creek, and now to Sahuarita High School. Courtesy *Green Valley News & Sun*.

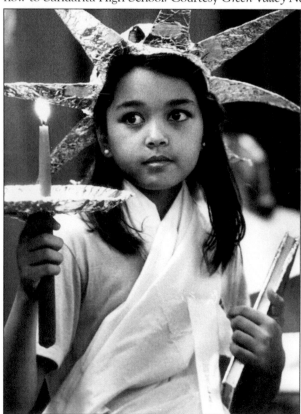

"THE PRETTIEST GIRL IN TOWN". Young Miss Olivia Moran in the 1970s wears a papier-mâché crown and holds a burning candle. She poses for a prize in a Statue of Liberty contest at the Good Old Fashioned Fourth of July celebration. The paper plate below the candle catches the hot wax drippings. Courtesy *Green Valley News & Sun*.

ADVENTURE. A taxi driver and his fare, Ida Ferlend, prepare to take off for an undisclosed destination. Was it in Green Valley, off to Tucson, or down to Mexico on the Old Nogales Highway? We'll never know, but the lady's coat indicates winter weather. The car is a 1970 Chevrolet. Credit Tebone. Courtesy *Green Valley News & Sun*.

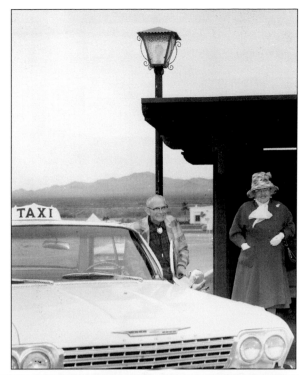

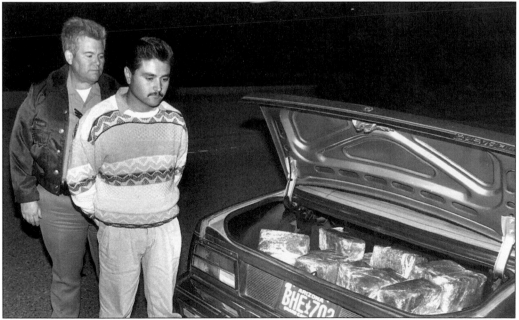

DARK ARTS. Sheriff's Deputy Bill Cassidy is apprehending a suspected drug smuggler in his Chevrolet on Interstate-19 at Green Valley. The highway, which is patrolled and offers assistance 24 hours per day, has long attracted illegal human and drug traffic from Mexico and Central America into the United States. Segments from the 1960s cover old riverine trails and El Camino Real, built with unpaid Piman labor under Spanish orders. The Green Valley interstate segment was begun in 1968. Courtesy *Green Valley News & Sun*.

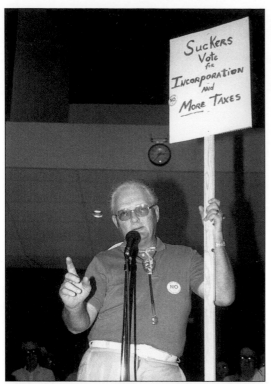

INCORPORATION. Blind Mr. Hurlbutt, who always wore sunglasses, displays his disapproval at an early attempt to incorporate Green Valley. Incorporation has been a hotly debated issue since 1977. Green Valley is not city, village, or town, but an unincorporated community that receives its government services from Pima County. The incorporation issue has been placed on the ballot four times. The voting proportions were typically one-third for incorporation, and two-thirds against. Registered voter turnout has been 70 percent. Courtesy *Green Valley News & Sun.*

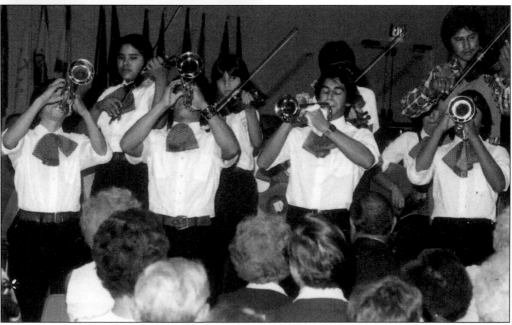

WALIA. The sounds of eight trumpets, three violins, and a bass fiddle fill the air, as young Hispanic musicians in Grupo Nuevo entertain Green Valleyites with their bewitching mariachi beat. On Tohono O'odham festival days, visitors can hear a five-piece Indian band—guitar, keyboard, drum, and saxophone—play the *walia* beat, their version of Hispanic *norteña* music. Courtesy Conrad Joyner-Green Valley Library.

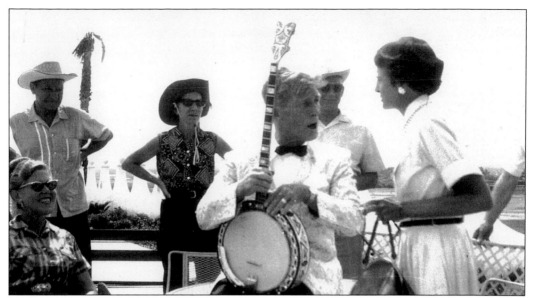

MUSIC. Eddy Peabody, a popular professional entertainer in a white tuxedo, courtesy the Maxon brothers, strums his banjo in the easy Green Valley society of the 1970s. Tebone was at the left and his wife Polly Hohler is seated. Guests arrive in western clothing, ready to listen and sing along. In the tiny Green Valley of those days, everybody knew everybody and all the widows were invited. Parties were held at the Haleway home, just north of the Cow Palace and across from the Kinsley Lakes. Courtesy *Green Valley News & Sun*.

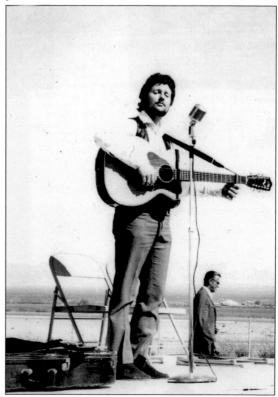

COUNTRY AND WESTERN. Tommy Tucker belts out a number in the 1970s. Country and Western, popular, classical, and Hispanic music have been popular since Green Valley was founded. Music has moved indoors to churches and centers, and is performed all year long. Courtesy Conrad Joyner, Green Valley Library.

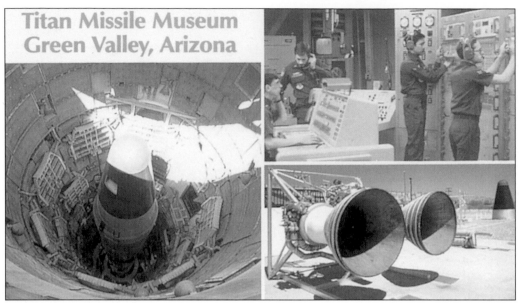

**Titan Missile Museum
Green Valley, Arizona**

POSTCARD, TITAN MISSILE MUSEUM. The Green Valley Titan II site was deactivated by the U.S. Air Force in 1981 and converted into the Titan Missile Museum in 1985. Titan was designated a National Historic Landmark in 1994. The photos show the tip of an actual Intercontinental Ballistic Missile warhead, pointing skyward; Air Force men are at work at the instrument panel and listening ears. Titan II was pronounced a success because it was never fired in anger. Courtesy Titan Missile Museum.

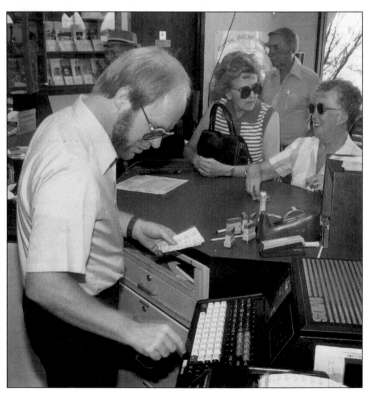

POST OFFICE. Pictured is Kenneth "Kenny" White at the second post office on Esperanza. This facility was upgraded to First Class in 1965 and relocated in 1988. Two women in sunglasses proclaim a bright March day. Kenny called these machines "ancient, " but they were new when they replaced the earlier generation. Today the office operates from a large postal complex on Continental Road, on the site of the old Rhodes Ranch, active in 1861. Courtesy *Green Valley News & Sun*.

POST OFFICE. On February 21, 1964, the Tucson *Green Valley News* reported: "Since Saturday, June 20, Green Valley has a post office of its own . . . the handsomest Fourth Class Post Office in the United States." Harold Binks, large figurative key in hand, smiles next to Green Valley's first Postmaster Katherine Heyl, still living in Green Valley in her own home. Katherine is poised to cut the ribbon and receive the key to the town. Guest postmasters from 16 communities and two nations attended the ceremony, including the Postmaster of Nogales with his entourage of three Mexican postal inspectors, adding "a flavor of international friendship." Heyl thanked U.S. Representative Morris Udall for his assistance in bringing the Post Office to Green Valley, her colleagues in Sahuarita and Tucson, and her husband, who made, in a pinch, "a fine errand boy and a good cook." The mood was described as "ecstatic delight." Courtesy *Green Valley News & Sun.*

PIMA COMMUNITY COLLEGE. Pima Community College of Tucson arrived early in the Green Valley Mall. Here an instructor teaches Spanish grammar to a class of new arrivals. One wears a *sombrero* to mark the occasion. The college is the fifth largest multi-campus community college in the U.S. and offers an eclectic menu in Green Valley. Courtesy *Green Valley News & Sun*.

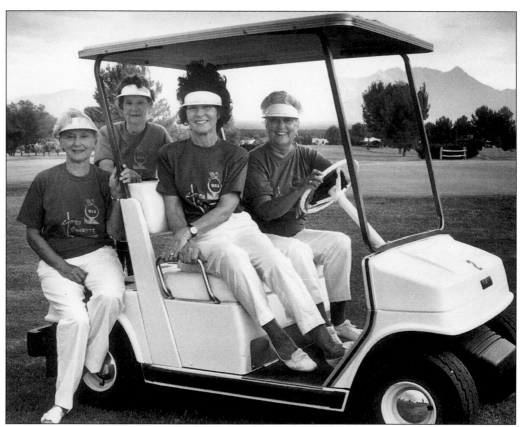

LADIES GOLF. A foursome of lady golfers joins the fun at Haven Golf Course in the 1970s, the oldest and most popular local links. This daily fee course plays to 6,868 yards. Pictured are, from left to right, Jean Henry, Helen Roney, Polly Robertson, and Ellen Fraser. Ellen drives her electric golf cart, Polly sits in the passenger seat, and Jean and Helen hang on. This golf lake and others is stocked with Amur (Siberian) carp to control water weeds. Courtesy *Green Valley News & Sun*.

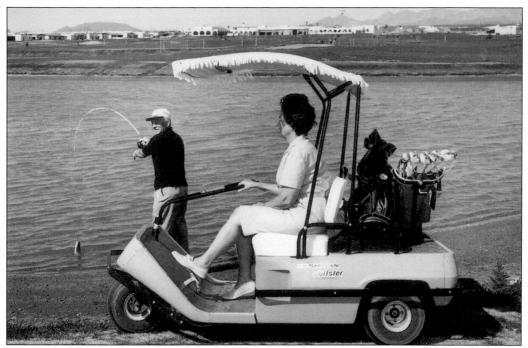

GOLF AND FISH. An unidentified golfer in her EZ-GO cart watches a fisherman haul in a carp from Haven Golf Club Lake. It was golf for two, and probably fish for two. The lake is across from the old Green Valley Recreation East Center, built in 1963 and 1964, and purchased by Green Valley Recreation in 1997. It is large enough to form occasional waves and catch golfballs. The electric-drive, three-wheel cart has a fringe on top and sets of his-and-her clubs. Courtesy *Green Valley News & Sun.*

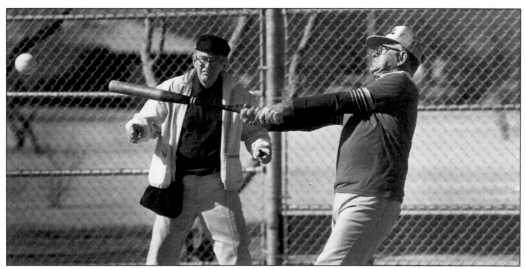

BASEBALL. While the plate umpire, wearing a beret, watches intently to make that all-important right call, an old-timer swings at the ball and sends it flying. In 1975, Anamax Mining Company donated 15 acres of land to the Sahuarita Unified School District to develop Anamax Park into a Pima County sports complex. Anamax now is the property of the Town of Sahuarita, three miles north of Green Valley and open to all. Courtesy *Green Valley News & Sun.*

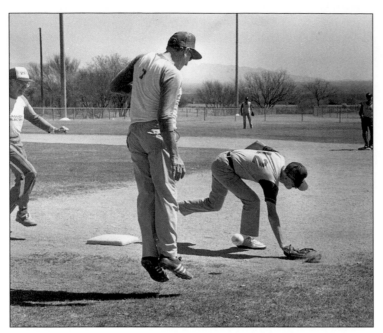

BASEBALL. Young and old in early Green Valley loved baseball and softball. Canyon Electric, an electrical contractor, sponsored teams in the early days of Anamax Park. In this glimpse, the first baseman's (team number 12) glove is empty and the ball is past him. The coach leaps into the air to get the best angle on the play as the base runner streaks for first. Second base and center field watch the fun. Courtesy *Green Valley News & Sun.*

LITTLE LEAGUE. It is not difficult to tell who won and who lost this 1980s Little League game under the lights at Anamax Park. Catcher Michael Foltz and third baseman leap and shout in joy. Pedro Valley and Raymond Moreno, the two losing boys, are the pictures of dejection. "Wait 'til tomorrow," they seem to say, but the victors don't hear. Courtesy *Green Valley News & Sun.*

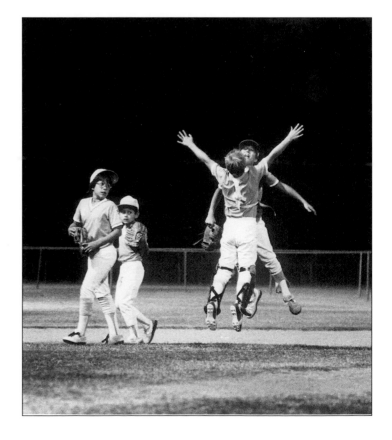

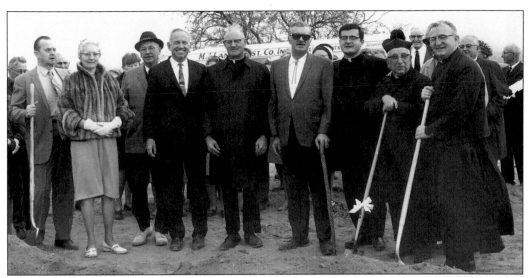

GROUNDBREAKING. Ground was broken for Our Lady of the Valley, April 1969. The building was dedicated in 1970. Pictured are, from left: contractor Matt Long; Mrs. Antoinette VanderMyde; Thomas Kullman, an early investor; an unnamed Carmelite priest; Mr. Henderson, with a sister's headdress peeking from behind; Charles Richardson of Maxon Construction; Father O'Leary; and Father Klinkhammer in biretta and cassock. The first pastor was Monsignor John Burns. Lang Construction, behind, was ready for operation. Courtesy *Green Valley News & Sun*.

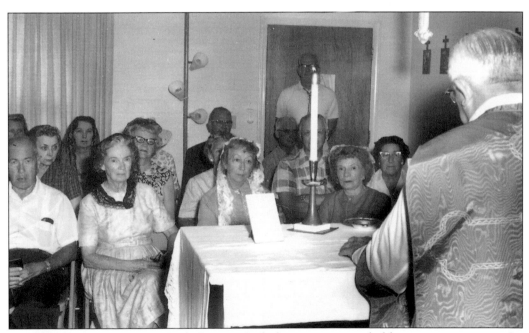

OUR LADY OF THE VALLEY. Early Roman Catholic services were held in an apartment on La Cañada, near Esperanza, then and now the center of town. Father Klinkhammer, his back to camera, conducts mass. The second Our Lady of the Valley building was completed in June 1970 and dedicated that November. The third and present site was dedicated in April 1990. Courtesy *Green Valley News & Sun*.

GREEN VALLEY COMMUNITY CHURCH. The Community Church opened on March 18, 1971, with services in the center of town and 80 charter members. The first church service in Green Valley was held on January 19, 1964, a non-denominational Protestant service in the fire station. Everyone in the community was invited and told to bring his own chair. Today membership exceeds 1,000. Courtesy Conrad Joyner-Green Valley Library.

ROADSIDE SHRINE. Just off the Old Nogales Highway, parallel to Interstate 19, a roadside shrine marks the spot where a motorist took a curve too sharply, drove off the road, and overturned, or skidded on a wet surface and drew his last breath. Mexican and Native American beliefs suggest the soul reposes here for a *novena*, nine days, in a temporary state of purgatory, although the body is elsewhere. Philip Goorian collection.

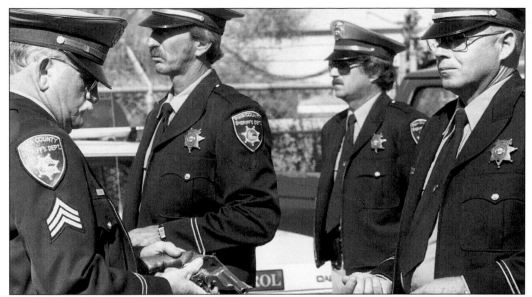

SHERIFF'S DEPUTIES. Sergeant Bobby Baker, left, Pima County Sheriff's Deputies, pulls a formal firearm, uniform, and vehicle inspection in the rear parking lot of the sheriff's office. Baker inspects Deputy James Junkerfields' revolver. In the 1960s and 1970s, inspections marked the commencement of each new shift. The Pima County Sheriff's Department is responsible for crime prevention in Green Valley. Courtesy *Green Valley News & Sun*.

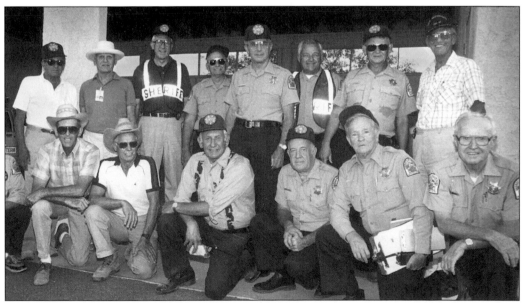

SHERIFF'S AUXILIARY VOLUNTEERS. These volunteers are, from left to right: (standing) Albert Rinda, Tom Gibbons, Larry Meyer, Nolan Frendedberg, unidentified, Lou Welden, unidentified, and Larry Black; (kneeling) Richard Otto, unidentified, Joe Letuks, Dick Cherweznik, Buzz Livsey, and J.A. Johnson. Dave Thomas is on the right. SAV, which started in the 1970s, operates under the slogan "Safe 24 Hours Each Day." It uses base stations, cars, radios, and unarmed volunteers to patrol streets, radio suspicious activity to the base, and cooperates with volunteer crime prevention programs. Courtesy *Green Valley News & Sun*.

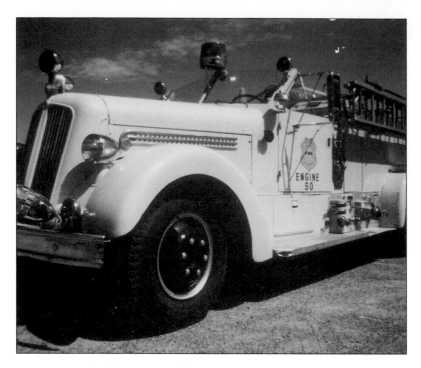

RURAL METRO.
Rural Metro
originally used
Fire Engine 50,
which Seagrave
manufactured
in Wisconsin in
1950. The engine
pumped up to
1,000 gallons per
minute. Engine 50
served all of early
Green Valley, as far
south as Amado
and north into
Sahuarita. It was
equipped with
ladders, sirens,
warning lights, and
two-way radios, and
responded to local
calls in three to
five minutes. The
first fire station was
housed in a building on La Cañada and Esperanza, which became Los Amigos Restaurant, now
the Old Fire House Restaurant. Courtesy Captain Ken Shultz, Green Valley Fire Department.

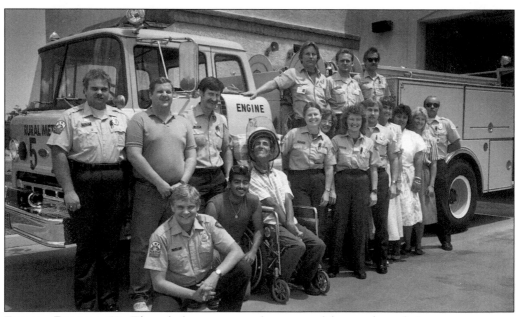

ENGINE PUMPER 52. The whole crew turned out to celebrate when their new emergency
vehicle arrived. At that time Valley Fire District contracted with Rural Metro Fire Protection
for police and fire protection. Fire protection has expanded to three facilities in town, La
Cañada and Desert Bell, Continental and Abrego, and Camino del Sol and Camino Encanto.
Courtesy *Green Valley News & Sun.*

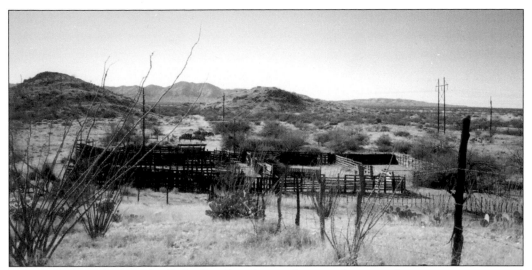

RURAL GREEN VALLEY. The Ruby Star Ranch corral, two miles west of town, was constructed in the late 19th or early 20th century. The four internal sections separated bulls, mature cows, heifers, and yearlings for sale, retention, branding, and castration. The corral has a squeeze chute and a ramp to move cattle in and to drive them out, and a drift fence to control cattle as they left the corral. The Sierrita Mountains form the background. Philip Goorian collection.

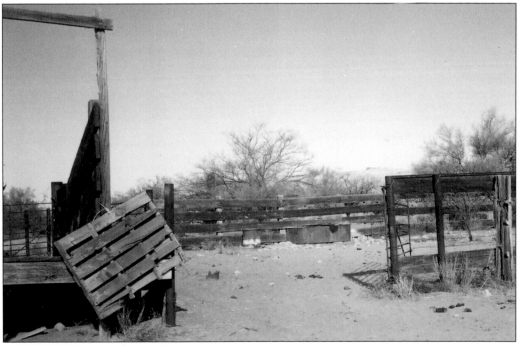

CORRAL. This is another early 20th century corral, near the intersection of Continental and Duval Mine Roads in rural Green Valley. Much of the community was open range for cattle grazing, especially in the northwest sector. Wherever housing developments have yet to be built, it still is. The chute, left, still hangs open to release cattle. The corral posts and old railroad ties stand firm after almost a century. The metal gate was originally used in mines. Philip Goorian collection.

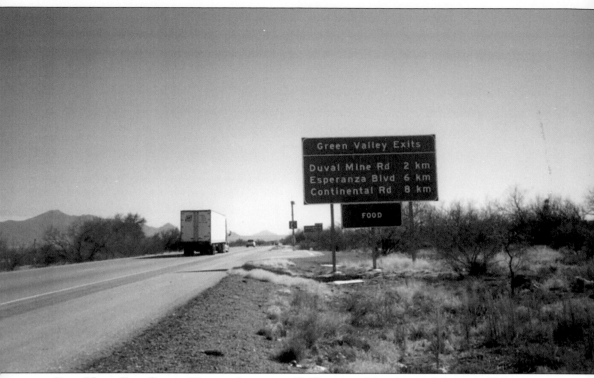

EXIT HERE FOR GREEN VALLEY. Interstate 19, Tucson to Nogales, and the only U.S. interstate segment signed in metric, runs through Green Valley. The community is 32 kilometers (20 miles) south of Tucson, and 69 kilometers (43 miles), north of Nogales. Esperanza Boulevard, the early exit, and Duval Mine Road and Continental Road will be supplemented by a new turnout to the Canoa Ranch. The speed limit, measured in miles, is 65 in populated areas and 75 in much of the open desert country. Philip Goorian collection.

Two

NATIVE AMERICANS

From 500 B.C.E. to 1450 A.D., Hohokam Indians, "people all used up" to the Pimans, lived in this area. The Tohono O'odham, their probable lineal descendants, followed a timeless and self-sufficient cycle of gathering wild desert plants, irrigating crops, and hunting. Many tribal members live on the reservation unit at Mission San Xavier del Bac, minutes north of Green Valley. Today, other opportunities beckon the nation, including Indian gaming at the two new Desert Diamond casinos.

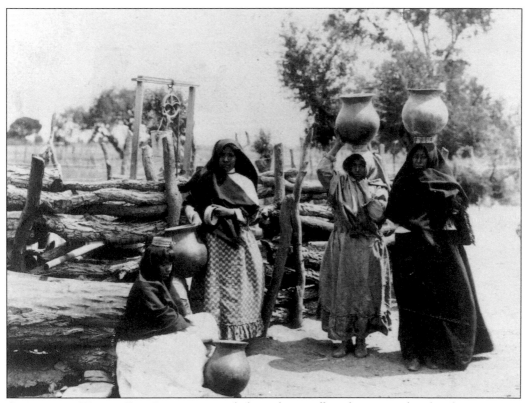

COLLECTING WATER. Four Papago women balance heavy *ollas* of water on their heads, or prepare to lift them, in this early 20th century view. *Ollas* are clay pots to hold water for drinking and cooking. Many of the trees in the background have been harvested for firewood. The thin shade cast by the remaining limbs and branches does little to reduce the effect of the burning sun, in this land of high temperatures and long summers. Courtesy Arizona Historical Society.

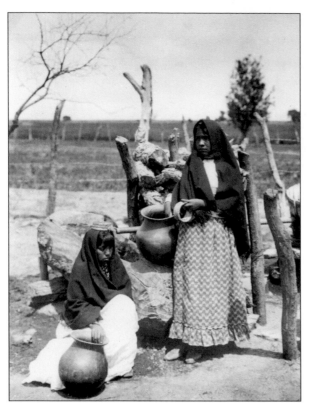

WOMEN AT WORK. Two Papago women in 1899 put down their *ollas*. The woman on the left is wearing a padded cloth to level the water-filled carrier on her head. Her loose black shawl provides some protection from the blazing sun. The water well, a popular meeting place, is on the right. Indians were self-sufficient before Spain arrived, irrigating crops from permanent springs at arroyo mouths. The Papago wove blankets and baskets and agave cloth (now a lost art), braided agave fiber into rope and string, and wove mountain yucca for needles and thread. They made baskets and gathered medicinal plants, ate mesquite bean pods, beargrass and cane cholla, trapped deer and hares, drank saguaro wine, and enjoyed roasted agave heart from the base of the trunk. All this happened in this arid area of Papagería, decades after the Gadsden Purchase. Courtesy Arizona Historical Society.

CAPTAIN JOSÉ. "Captain José (our Papago guide) wore only a plain blue coat with brass buttons in front, white cotton pantaloons, buckskin leggins and moccasins of the same, all a little the worse for wear and tear. Captain Jose speaks good Spanish, and is a man of excellent character, remarkable for his sobriety and good sense." Credit J Ross Brown, *Adventures in the Apache Country, A Tour Through Arizona and Sonora, 1864.*

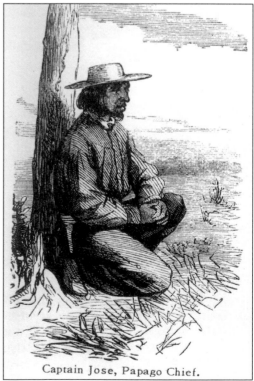

Captain Jose, Papago Chief.

36

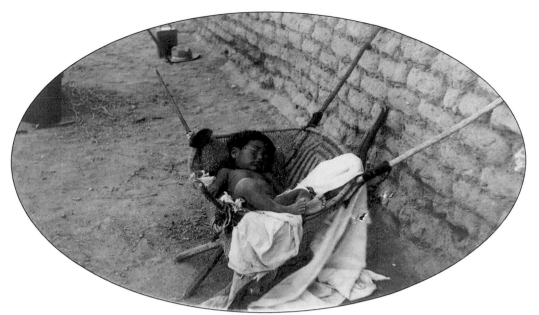

MAN AT REST. A young Papago chief enjoys his nap under the direct sun. The agave straps of his hammock provide air space on both sides, top, and bottom. The straps are secured into the walls of his home by pegs, between rows of sun-baked adobe brick. Courtesy Arizona Historical Society

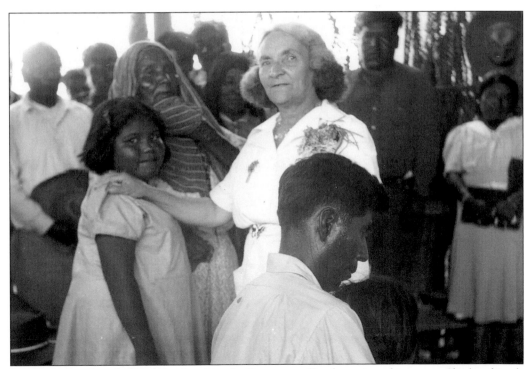

FAITH. An unidentified faith healer visits the Papago to effect her miraculous cures. She lays hands on a young Papago girl, while other tribal members, men, older women, and boys, await their turn. Indian Health Service hospitals serve the Nation today. Courtesy Arizona Historical Society.

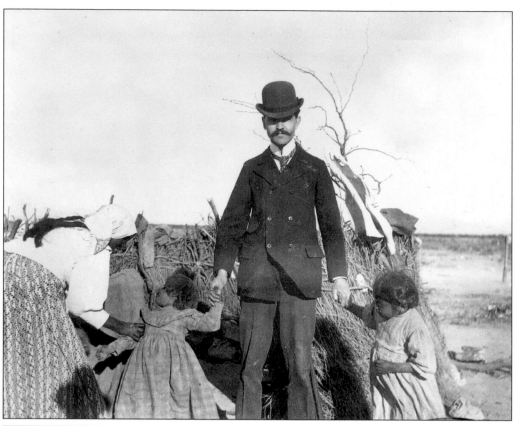

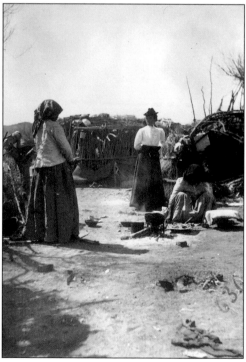

MR. ROMIZER. At the turn of the 20th century it was fashionable for Tucsonans to meet the Indians at home. In 1899, Mr. Romizer, Tucson tourist and photographer, made one of his frequent camera visits to the Tohono O'odham, then known as Papago. He takes two small girls by the hand, as their mother watches on. In his tight black suit, high collar, narrow tie, and Homburg hat, this turn-of-the-20th century visitor could not have dressed more carefully and less appropriately for the climate. Courtesy Arizona Historical Society.

MISS MORGAN. On March 23, 1899, Miss Morgan visited the Bac community, 20 miles south of Tucson. She wears the latest choking style, down to her high button shoes. She and a Papago mother stare at each other, as another woman prepares food. A wooden fence in the background, ocotillo and mesquite, and two brush homes complete the picture of the Papago homemaker at home. Courtesy Arizona Historical Society.

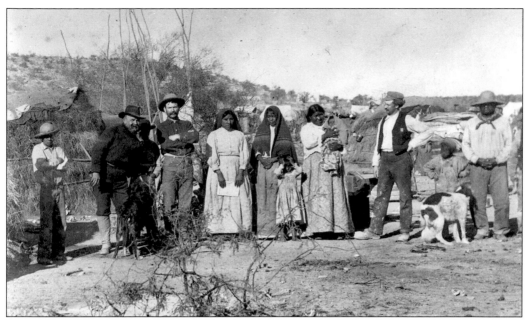

TOURISTS. Three white men, one evidently a soldier on active duty in the U.S. Army, mingle with two Papago men and three Papago women, one with a babe in arms. Two Papago children and a dog complete the picture of early tourism. Courtesy Arizona Historical Society.

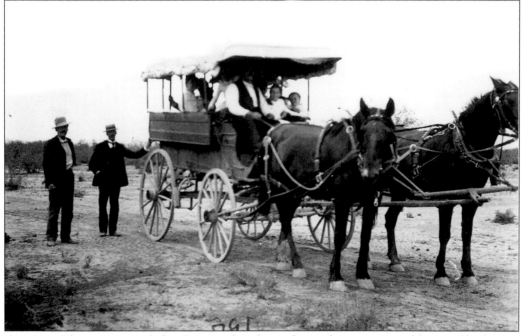

WAGONS. This party traveled to Bac in a handsome horse-drawn team and buggy. The buggy, pulled by a team of black horses, had a surrey on top and wooden sideboards. While two men stand outside, the driver, a woman, and a boy wait for the photographer to finish so they can continue to Bac village. Courtesy Arizona Historical Society.

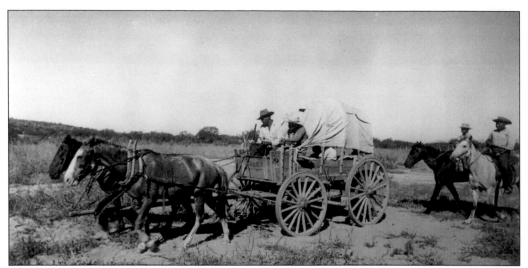

INDIAN TRANSPORT. The Papago liked transport, too. In this picture an Indian team, pulling a covered wagon loaded with two men and two children, makes its slow, bumpy way over a desert road to the Mission. A pair of mounted Papago cowboys follow. Everyone wears cowboy hats against the grueling sun. Courtesy Arizona Historical Society.

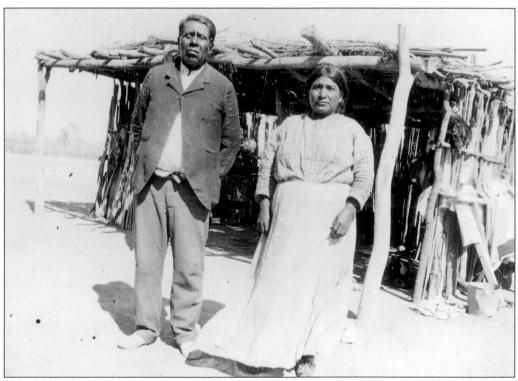

FAMILY. An unidentified Papago couple stare at the camera in front of their desert home. Sturdy mesquite or cottonwood trunks, used for construction in the early Santa Cruz River Valley, anchor the structure. The man dresses in a style common among American workingmen in the 1890s. The woman's long skirt has since given way to mainstream American styles, but many Papago women and girls still braid their long black hair. Courtesy Arizona Historical Society.

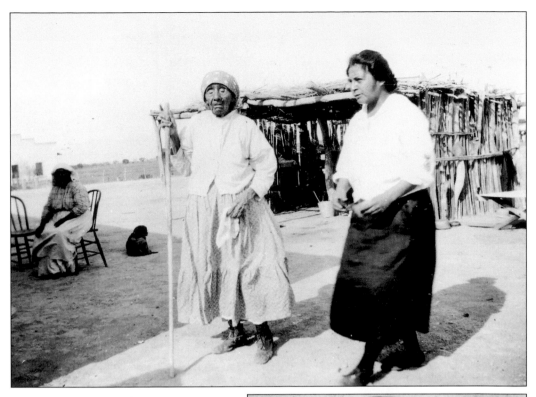

JUANA. Juana, an aged Papago woman, receives a Hispanic visitor, who apparently has come to chat. Juana was a popular turn-of-the-20th-century photography subject, but her family name is not recorded. She poses in front of her daub and wattle home, open for cooling breezes to pass through. Courtesy Arizona Historical Society.

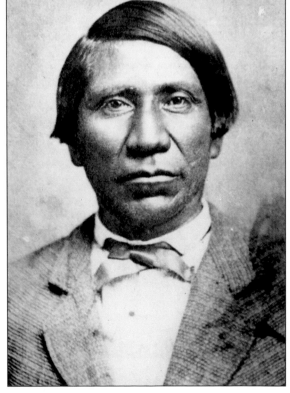

CHIEF CHARLES. Not everyone on the Papago Nation was a Papago. Father Kino established San Xavier del Bac Mission in 1691, on personal invitation by Sobaipuri and Papago Indian chiefs from Bac. Later, Spanish padres reinforced Tohono O'odham with Sobaipuri Indians. Chief Charles was the last Sobaipuri chief. He ruled his people at Bac for 30 to 40 years. The Sobaipuri dwindled and eventually became extinct, easy prey to European-introduced epidemics. Courtesy Arizona Historical Society.

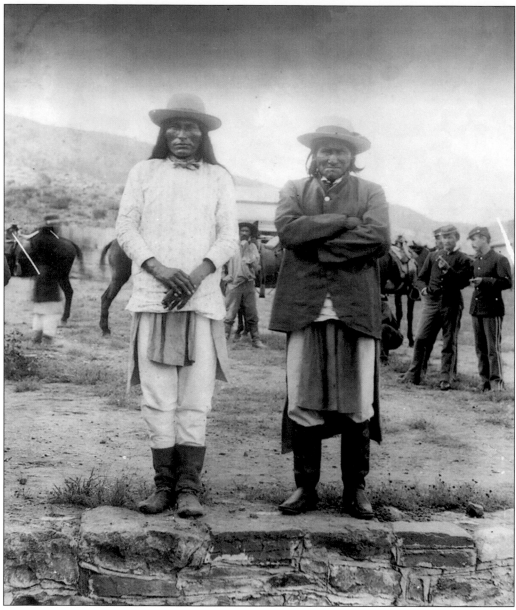

GERONIMO. Pictured are Naiche, a Chiricahua Chief, on the left and the famous Geronimo at the right, in Fort Bowie, Arizona. This photo was taken September 6 or 7, 1886, just before Geronimo's exile in Florida. Heavily armed U. S. Army soldiers are very prominent in the background. Apache warriors raided Bac, Tubac, and Tumacacori. Chief Geronimo raided a corral at the Brown Ranch house, and stole horses and cattle, in the area Rancho Sahuarita today. When Geronimo was exiled the Apache Wars ended. Courtesy Arizona Historical Society and *Green Valley News & Sun*.

Three

MISSIONS

On June 16, 1858, Phocian R. Way, diarist, engraver, and miner from the Santa Rita Mining Company of Tubac, described San Xavier Mission. "The church is built of burnt brick... and is ornamented both outside and inside by numerous statues. The walls are very thick and there are no seats. The interior is elaborately carved, painted, and bronzed. There are several very large paintings on the walls representing religious subjects. . . . Some have been almost obliterated by time, but most of the statuary and ornamental work is complete... The natives look upon the structure with a feeling of awe. . . . If this country should ever again become thickly populated, it will be renovated and repaired and again used as a place of worship."

SAN XAVIER DEL BAC. "The San Xavier del Bac mission is one of the most beautiful and picturesque edifices of the kind to be found on the North American continent. I was surprised to see such a splendid monument of civilization in the wilds of Arizona. The front is richly ornamented with fanciful decorations in masonry; a lofty bell-tower rises at each corner, one of which is capped by a dome; the other still remains in an unfinished condition. (note: the second tower is still unfinished.) Over the main chapel in the rear is also a large dome; and the walls are surmounted by massive cornices and ornaments appropriately designed. The material is principally brick, made, no doubt, on the spot. The style of architecture is Sarasenic (Moorish or Arabic). The entire edifice is perfect in the harmony of its proportions." Credit J. Ross Brown, *Adventures in the Apache Country, A Tour Through Arizona and Sonora*, 1864.

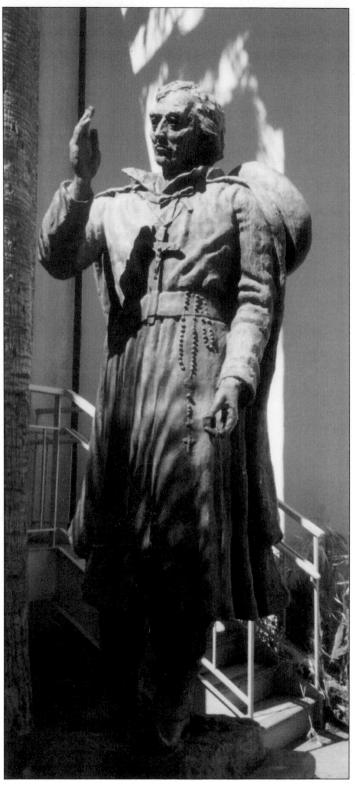

FATHER KINO. Father Eusebio Francisco Kino made more than 50 major journeys on foot and horseback in the late 1600s and early 1700s, and founded 21 missions in Sonora and Arizona, including San Xavier del Bac, Tumacacori, and Guevavi. A replica of his statue at the Tucson Historical Society, cast from the original in Washington D.C., shows a strong profile, a hawk-like nose, and a determined stare. Father Kino, a Jesuit "black robe," an indefatigable priest, proselytizer, explorer, cartographer, astronomer, administrator, botanist, farmer, and stockman was the first permanent missionary to the Indians in present-day Arizona. He was born about 1645 in the Alpine town of Segno, Italy. As a student, sick almost to death, he dedicated his life, should he recover, to San Francisco Xavier, his martyred patron saint. Although his saint never saw the New World and died in Portuguese India, the Order assigned Kino to New Spain in 1687 to convert the Indians to Christianity. Father Kino treated the O'odham with kindness and respect, enriched the subsistence diet with wheat and barley, and introduced horses and cattle. Philip Goorian collection.

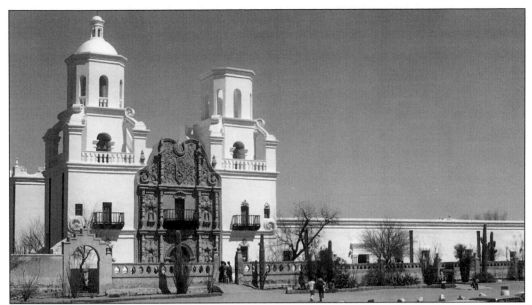

THE MISSION. San Xavier Mission blends Catholic Spain, Byzantine, and Mexican baroque into a flowing design. The building, started by Father Kino around 1692, is dazzling white. The towering dome is constructed from burned adobe brick laid on a stone foundation. Mesquite beams, reinforced by dried ocotillo ribs, form the *convento* (outer building). The west bell tower is complete, while the east tower stands unfinished. Carved curlicues and arabesques and the Franciscan coat of arms cover the upper level, and a pair of 20th century silver rattlesnakes entwine the handles of the front door. Courtesy *Green Valley News & Sun.*

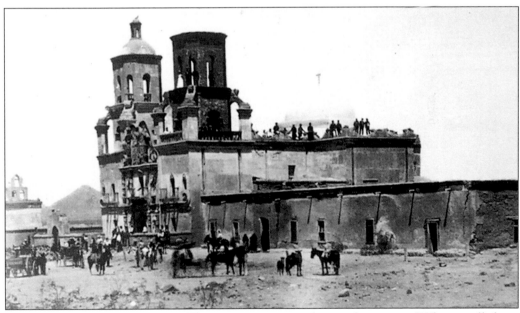

SAN XAVIER DEL BAC MUSEUM. The museum poses a whimsical question: "Who are all these people? Why are they on the roof of the Mission? Is it a special holiday, a wedding party? We do know that this photograph was taken prior to 1887 and is one of the most unique glimpses of the 19th century San Xavier Mission." Courtesy San Xavier del Bac Mission Museum.

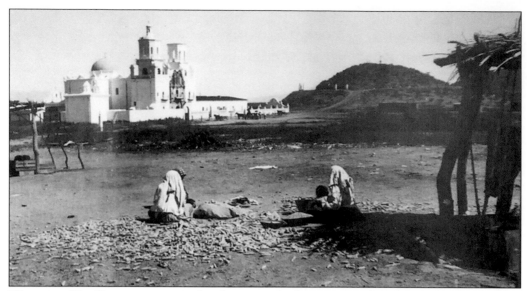

WORKING. Two Papago women, in shawls against the fierce sun, work in the open space, or plaza, immediately in front of San Xavier del Bac Mission. A *ramada* provides shade. The old ways of traveling by wagon, constructing adobe homes, and processing native food survived until a few short years before this photo was taken in the early 1900s, in the village of Bac. This open area now is a parking lot for Mission visitors. Courtesy San Xavier del Bac Mission Museum.

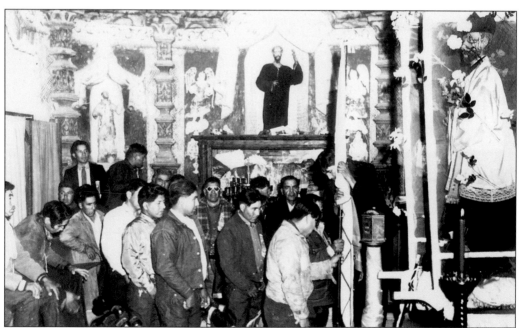

PRAYER. Worshippers kneel before the altar. Phocian Way said on June 16, 1858: "… the walls are very thick and there are no seats. The interior is elaborately carved, painted, and bronzed. There are several very large paintings on the wall representing religious subjects, but they are not fine specimens of art. Some have been almost obliterated by time, but most of the statuary and ornamental work is complete." Way's "obliteration by time" has been reversed—the interior of the Mission is renovated. Courtesy Arizona Historical Society.

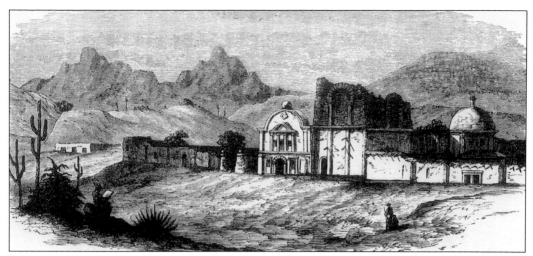

TUMACACORI MISSION. "We made a halt to visit the old mission of San José de Tumacacori, another of those interesting relics of Jesuit enterprise which abound in this country. The mission is pleasantly situated on a slope within a few hundred yards of the Santa Cruz River, with a luxuriant growth of cotton-wood, mesquit (sic) and shrubbery... The dome, bell-towers, and adjacent outhouses are considerable defaced by the lapse of time, or more probably by the vandalism of renegade Americans." Browne is pictured in the left foreground, and an American woman is at the right. Credit J. Ross Brown, *Adventures in the Apache Country, A Tour Through Arizona and Sonora*, 1864.

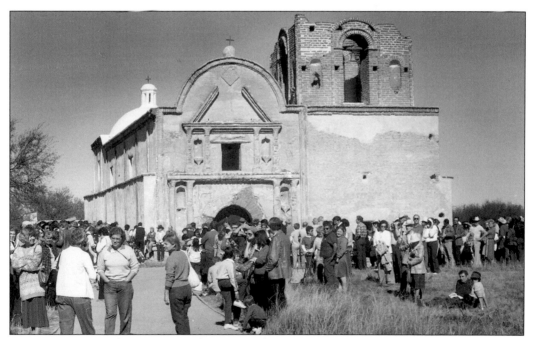

CCELEBRATION. A large group gathers at weather-worn Tumacácori Mission to commemorate a special event. Although the old church no longer holds regular religious ceremonies, in October, at the Fiesta de Tumacácori, a misa mayor, or High Mass, is celebrated. People arrive in period dress for mass and blessing of Anza Days, in this Franciscan architectural treasure. Courtesy *Green Valley News & Sun*.

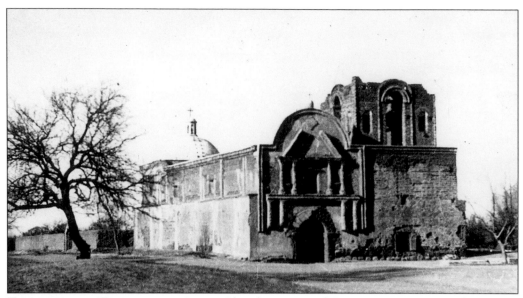

TUMACACORI IN PERSPECTIVE. George Chambers wrote of Tumacacori in 1972: "…the ancient mission, with its awesome six-foot walls, is an impressive monument to the manual labor of the Indian converts who built it, and the zeal of the Spanish padres who were the first to preach the Gospel in the New World." At Christmas the abandoned building comes alive and the lanes gleam with luminarias, candles burning in brown paper bags. Photo Mary Hugston, 1968, courtesy *Green Valley News & Sun*.

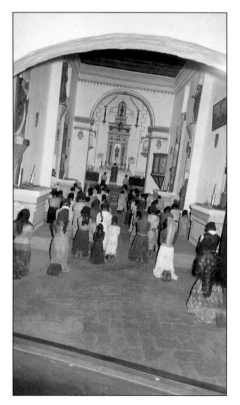

DIORAMA. These figurines—Indians, Mestizos, and Spaniards—genuflect before the altar, c. 1824. The Tumacacori Mission colors are brilliant, statues hang from the white walls, candles appear to burn, and the confessional stands ready to receive penitents. Barefoot Indians wear modest dress and long, black, braided hair. A soldier, pictured at the right front, flamboyant in orange shawl, white shirt, blue trousers with yellow figured frogs, boots, and red sash, kneels beside a lady of Spain in her flowing manton of manila. This *soldado* is actually a miniature representation of one Bartlett Frost, the Civilian Conservation Corps artist who produced the diorama in 1935. Philip Goorian collection, courtesy Tumacacori Mission National Monument.

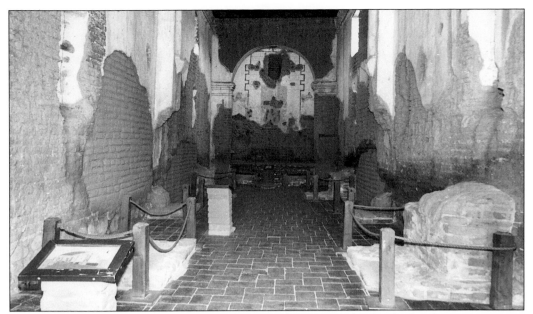

ABANDONED. Inside the mission church, where worshippers stood or knelt, the alcoves are empty. Initials are tastelessly carved into adobe brick walls. Swatches of the original reds and blues lurk in engraved circles in the center of the nave, a few haphazard spots on the cornices and above the altar. Small floral designs, their colors almost vanished, are inscribed in the walls, which are still structurally sound but stand bare to reddish adobe brick. Courtesy *Green Valley News & Sun.*

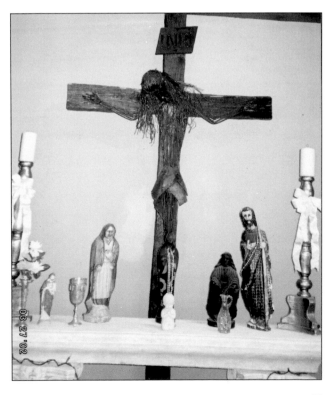

ELGIN. The tiny village of Elgin, east of Green Valley, was a ranching headquarters in the early 19th century. The small church, *La Capilla Santa Maria Consoladora de Los Afligados* (Chapel of Maria Consoler of the Afflicted), features a crucifixion scene. An artist from Nogales, Arizona, blind since birth, fashioned the work entirely of welding rods. Philip Goorian collection.

49

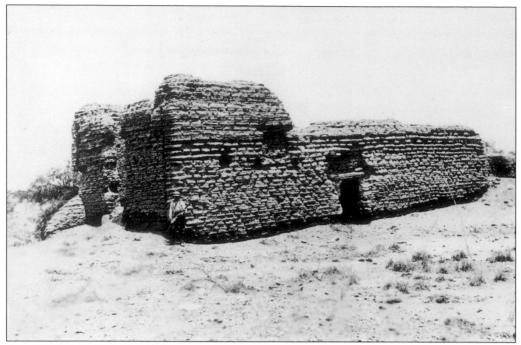

GUEVAVI MISSION. Jesuit Father Kino founded the mission church and visita of Santos Angeles de Guevavi in 1691. The order promoted it to district headquarters in 1701. Father Juan de San Martin erected the nave and sanctuary in 1751, and Father Garucho the entry hall and tower from 1754 to 1758. In 1771, the Franciscan Order vacated Guevavi Mission in favor of Tumacacori, but used the church until 1822. Today, only ruined adobe walls and a few low mounds mark the site. Courtesy Tubac Historical Society.

CALABASAS MISSION. Pictured, left to right, are: James E. Ayers, archeologist, Arizona State Museum; Bernard (Bunny) Fontana, historian, author, and ethnologist, Arizona State Museum; and Will Rogers Jr., son of the famed American humorist. Jesuit Father Francisco Xavier Pauer established the San Cayetano de Calabasas Mission in 1756. The Jesuits discontinued it in 1786. The Franciscans struggled to keep the mission alive despite a lack of funds and support from Spain, but under the blows of malaria and Apache assault, Calabasas and its Indian villages fell into ruin. Photograph by Helga Teiwes, Arizona State Museum, courtesy Tubac Historical Society.

Four

CONTINENTAL

The old farm settlement and picturesque village of Continental, almost enveloped by Green Valley, is a collection of rural homes and a handful of new light industries nestled in pecan groves. Continental has large adobe houses, winding, unpaved streets, enormous trees, and a median age decades younger than Green Valley.

During World War I, President Woodrow Wilson asked the Intercontinental Rubber Company, Joseph Kennedy Sr.(father of then future president John Kennedy), J.P. Morgan, and Bernard Baruch to grow guayule. This southwestern shrub contains latex, the base of rubber. Intercontinental built processing facilities, and the village had a general store and a church. Queen Wilhelmina of the Netherlands farmed cotton here in absentia from 1922 to 1949, and some 40 German prisoners of war worked in the fields in World War II.

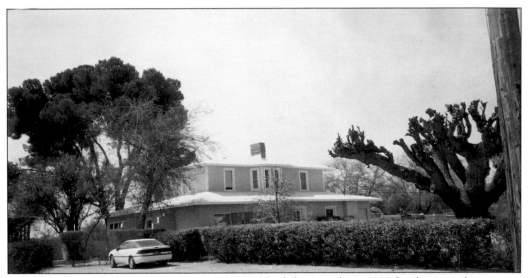

OLD CONTINENTAL VILLAGE. Intercontinental built houses about 1918 for the guayule growers. This two-story house became home to Keith Walden, founder of FICO. It has a sleeping porch, verandas, and dense foliage and screening, which moderate the indoor temperatures. A post office operated in Continental from May 26, 1917 to February 28, 1929. Philip Goorian collection.

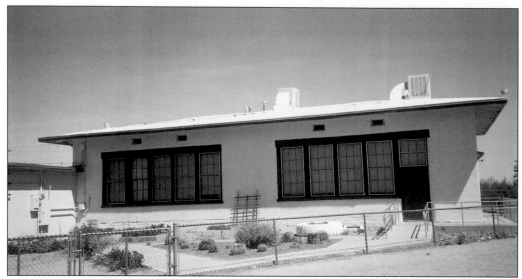

OLD CONTINENTAL SCHOOL. The original school in Continental, built in 1918, has been refurbished with air conditioning and playground equipment. Classes were held until the 1990s. Continental School was one of the first school districts to integrate in Arizona, serving both the Papago children who lived and worked on Bull Farms and Bull Ranch in 1940-1969, and African Americans. The building is now a community and health center. Philip Goorian collection.

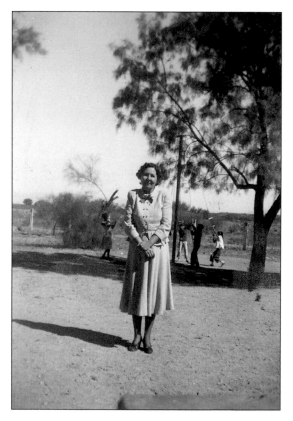

MRS. O'BRIEN. Mrs. Bess O'Brien stands at the playground in a photo taken about 1949. She was Continental School principal and taught the 6th, 7th, and 8th grades from 1942 to 1966. Several students play in the background. A plaque erected at the school reads: "Dedicated to the memory of Bess O'Brien. A teacher at the Continental School from September 1942 through December 1966. In memory she lives on in those minds made better by her devoted teaching". Courtesy Lynn Harris, historian, McGee Ranch Settlement.

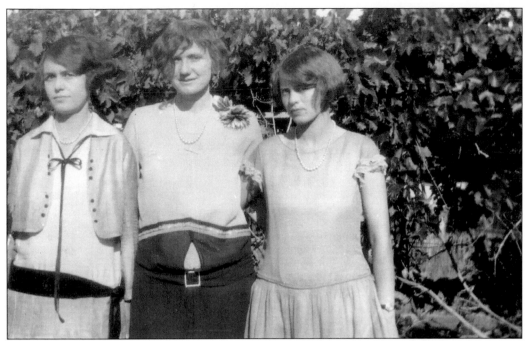

TEACHERS. Pictured here are Continental teachers, from left to right: Mildred Helfenstein, Mrs. O.C. Meadows, and Estelle Overpeck. In 1921, Continental School had a student body of 41 and 155 in 1924. They arrived by car in what must have been a very dusty trip, to deepest Arizona. Courtesy Continental School Oral History, 8th grade teacher Jean Fuer.

GRADUATION. Eighth grade graduation at Continental School in 1927. From the left are Nellie Acosta, Gladys Bull, and Loretta Martin. From that time on, the student body expanded. Courtesy Continental School Oral History, 8th grade teacher Jean Fuer.

STUDENTS. Pictured are Janie and her brother Jimmy Bowder, dressed like a miniature cowboy, and their pet dog, at Continental School in 1942. Behind them are electricity poles and wires and a transmission tower, mesquite trees, mailboxes, and homes, in a typical rural Arizona scene of the times. Courtesy Lynn Harris, historian, McGee Ranch Settlement.

STUDENTS. These Papago children are ready for school. The siblings with their winning smiles are Laura Ann, Elaine, and Jimmy Lewis, children of Continental and Bull Farm employees. Behind are a sturdy cattle gate and dry pasture. Contintental was a crop and cattle center. Courtesy Gladys Bull Klingenberg, Green Valley.

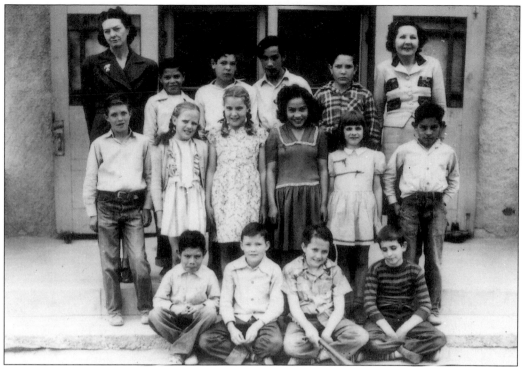

GRADUATION, 1946. Pictured, left to right, are: (back row) teacher Mrs. Templeton, Manuel Acuña, Jimmy Bowden, Ramon Teso, Jimmy Luker, and teacher Bess O'Brien; (middle row) Jerry Luker, Nancy DeCamp, Shirley Jones, Rosa Teso, Spaulding's sister; and Joe Teso; (front row) Henry Teso, Joe Martin, Marshall Lever of the Santa Rita Lodge in Madera Canyon, and Spaulding Brown. Courtesy Continental School Oral History, 8th grade teacher Jean Fuer.

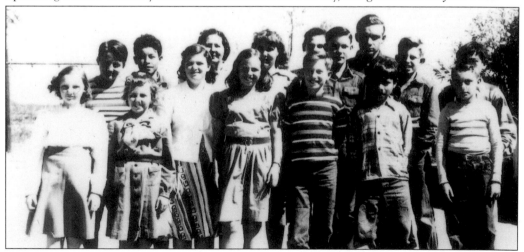

MIDDLE GRADES, 1950. Pictured are the 5th through 8th grades: (back row) Marshall Lever, Art Marsteller, Bess O'Brien, Shirley Jones, Donald Aldridge, Joe Martin, Johnny Klingenberg, and Eugene Lay; (front row) Rose Lee Aldrich, Betty Sixth (a relative of the Klessigs who ran the Continental Store), Janie Bowden, Julia Brown, Danny Klingenberg, Henry Teso, and Lynn Gagnon. Photo source, Joe Martin, Courtesy Continental School Oral History, 8th grade teacher Jean Fuer.

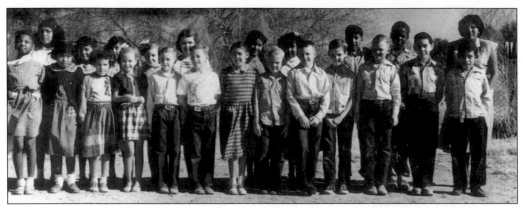

UPPER GRADES, C. 1954. Pictured are the Continental School upper grades, left to right: (back row) two unidentified, Veronica Nora, Dorothy Slusher, Martha Galvin, Frances Molina, Martina Bautista, Kenneth Chico, and unidentified; (front) unidentified, Lorraine Juan, Socorro Teso, Elsie Slusher, Jerry Hibberts, Curtis Adam, Rosie Mollon, Buddy Ray, Tom Walden, Bill Slusher, Dickie Ray, LeRoy Proctor, and Arnold Teso. Courtesy Continental School Oral History. Photo source, Frank Teso, 8th grade teacher Jean Fuer.

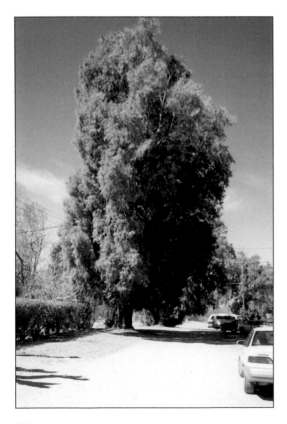

TREES. Trees grow tall in old Continental Village. This cedar, probably planted when the village was established in 1916, has no rivals in surrounding Green Valley. The gravel road adds to the rural atmosphere, which has endured since the founding. This photo was taken in 2002. Philip Goorian collection.

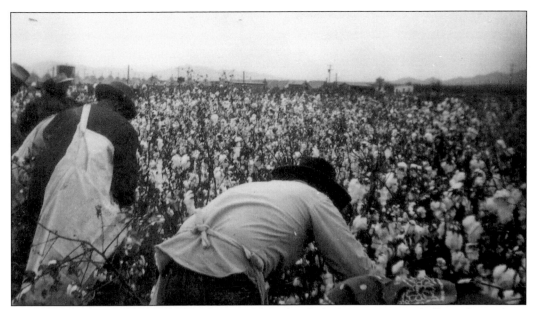

PICKIN' COTTON. Migrant farm hands bend low to pluck the ripe cotton bolls and get them into their sacks. The thick stand indicates a bumper irrigated crop. Itinerant workers were recruited in Texas and brought to Continental on large trucks. They picked each acre up to three times in September and October, and when the harvest season ended, were returned to Texas. A farmhouse is way off in the right distance. Migrants also worked corn, barley, peas, and watermelons. Those were not the "good old days." Continental School Oral History, 8th grade teacher Jean Fuer.

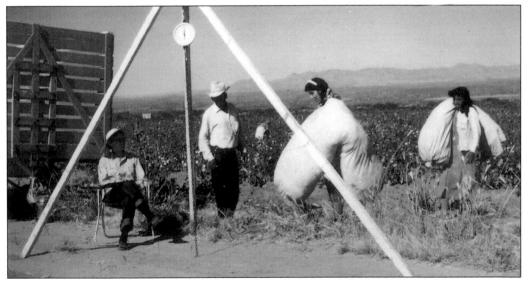

WEIGHING IN. After the Papago women filled their sacks, the weight was recorded, the sack emptied into the wagon on the left, and the pickers went back into the field for another load. The cotton fields were almost waist-high, according to Mrs. Louise Mosley, who arrived before 1949 and is still a Continental dweller, and the pickers were black, white, Indian, and Mexican. There was no mechanical harvesting then, and everyone who could pick, did so. Courtesy Continental School Oral History, 8th grade teacher Jean Fuer.

BULL FARM. Janie Bowden leads Sharon and Judy Davis, wearing life preservers, for some summer irrigation ditch fun on the Bull Farm, near Continental, in 1952. The farm headquarters are almost lost in a grove of trees. James Bull paid back taxes to acquire his first 160-acre plot and raised alfalfa, vegetables, and grains from 1926 to 1975. At its peak, Bull Farms worked 6,150 acres. In 1989 it became Quail Creek, a retirement development center adjacent to Green Valley. Courtesy Lee Harris, historian, McGee Ranch Settlement.

THE WESTERNER. *Wildcat* reporter Jackie Kaspar interviewed Gary Cooper, filming *The Westerner* on Bull Farm, November 24, 1939. Jackie wrote, "Six-foot-three-inches of the swellest-looking guy I had ever set eyes on stood before me." As two extras feign disinterest, the microphone on the boom catches all the verbal action as two young actors duke it out. Courtesy Continental School Oral History, 8th grade teacher Jean Fuer.

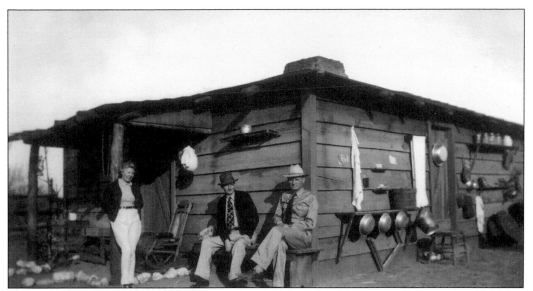

ACTORS. Near the climax of the film, members of the cast gather amiably at the old wood frame headquarters. The walls are hung with pots, pans, and towels used at that time The fire scene was shot here because a cornfield was available, and the ears were harvested in advance, to earn some money on the crop (the corn stretched over Gary Cooper's head). Courtesy Continental School Oral History, 8th grade teacher Jean Fuer.

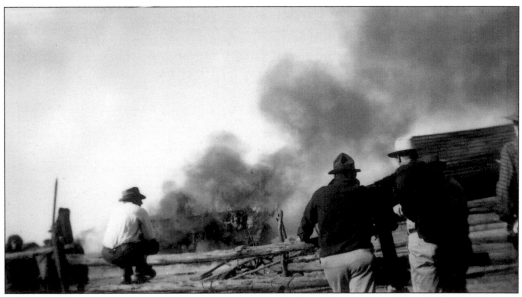

FIRE. Actors perch on the fence line to watch the fire devour the old wood frame headquarters. Smoke billows as the former family home is incinerated for art's sake. The supporting cast included Walter Brimmon, Fred Stone, Dana Andrews, and Doris Davenport. Samuel Goldwyn produced the film. Courtesy Continental School Oral History, 8th grade teacher Jean Fuer.

CONTINENTAL CEMETERY. Madera Reserve, a new upper income, non-age restricted housing development, asked the Continental Community Council, which represents nine Native American families, their wishes for the old Continental cemetery. All wanted to preserve and protect the burial ground, install a concrete perimeter wall, admit visitors, allow 10 more burials, and grant visitation in perpetuity. Mrs. Maria (Mary) Esparza, chairperson of the Council and a Yaqui Indian, who spoke not a word of English until she was six years old, explained in unaccented English, "We couldn't be more pleased. We want to maintain the holy site and clean it on *el Dia de los Muertos*, the Day of the Dead. This is very important to us, and this is what we want. I look at the mountains, think about the people." Old Continental rests here; Lopez, Sawagi, Castillo, Vasquez, Salcito, Olivas, Valladolid and more, from 1903 onward. Some graves are unmarked, except for stones. The holy site is preserved. Philip Goorian collection.

Five

SAHUARITA

Old Sahuarito (now Sahuarita), or little cactus, was attacked by Apaches. The village, school, and post office were abandoned, until settlers returned with peace in 1886. In those early days, settlers lived in canvas tents with wooden floors, water was drawn from private wells, and irrigation canals doubled for a laundry. The first electricity lines were strung from house to house. That schoolhouse has completely disappeared, but remnants of the second school are still visible off Santa Rita Road. The railroad from Sahuarita Depot to Nogales and Tucson provided transportation. Sahuarita has miles of irrigated pecan orchards, enormous active copper mines as well as remnants of many abandoned mines, and new housing development.

JAMES KILROY BROWN FAMILY. Pictured, left to right, are: (standing) John Brown, Keno Brown, Roy Brown, and Tootsie Brown; (seated) Ann Lewis Blackmore and Billie Brown. In the front are Annie Brown and Ruth Olive, Blackmore grandchildren, visiting at Sahuarito ranch about 1896, and James Sr. The Brown family ranch home had a roofed patio to divert the direct sun, and a giant saguaro and windmill, left rear. The ranch house was on the old Emigrant Trail, west of the Santa Cruz River. In November 1877, the *Tucson Weekly Star* reported: "Messrs. Roddick (Brown's partner) and Brown have purchased Sahuarito Ranch, located 22 miles south of Tucson (adjacent on the north to future Green Valley) for the benefit of the traveling public. Meals will be served at all hours of the day and night. They will also keep on hand hay and grain for stock." Brown's stagecoach stop served such local delicacies as (Gambel) quail on toast. The coach ran from Tucson, San Xavier Mission, Sahuarito, Amado Half Way House, Calabasas, and Nogales, Arizona. Courtesy Arizona Historical Society.

JAMES KILROY BROWN AT HOME. In 1892, left to right, Olive "Ollie" Brown, James Kilroy "Jim" and Clara "Keno" Brown in front of their vine-covered, well-constructed Sahuarito home. Mr. Brown, portly, genial, and commanding, was elected sheriff of Pima County Kilroy. After Browne's death, his adobe house began to melt into the desert. People from Tucson came down and removed the sturdy beams for a ramada. Only scattered nails remain on and under the ground. Courtesy Arizona Historical Society.

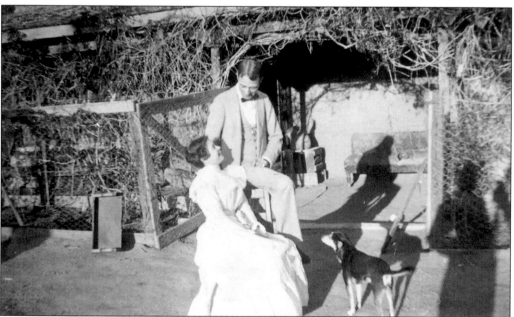

COURTING. Clara (Keno) Beatric Brown, and Bean (nickname) at Sahuarito Ranch and Stage Stop in 1897. A pet dog stares at the intruder. The brush around the home provides shade and helps to keep the temperatures down and the wire screen keeps varmints out. Courtesy Arizona Historical Society.

SAHUARITA VILLAGE. This is the Castillo residence in the old village of Sahuarita. The 20 families date back before the Gadsden Purchase, and Spanish was the primary language until the 1950s. Resident Grace Anguilo Teso remarked, "We see each other as a big family." The village lies on land once part of the old Brown Ranch. In 1942, Lamberto Castillo, a miner from Helvetia, built his home on the corner of La Villita (small village), a major stagecoach line along the Santa Cruz River from Tucson to Nogales. Courtesy Mrs. Mercy Teso and Dr. Richard Grabowski, *The Sahuarita Times*. Philip Goorian collection.

OLD SAHUARITA SCHOOL. The old brick Sahuarita School building educated students from the early 1940s to 1957, then was abandoned. It was partitioned into three areas: left side for the 3rd grade, the long center room separated by bi-fold doors for 4th and 5th, and the east end, 2nd grade. In the government barracks were 6th through 8th grades. The earliest school was built around 1885 on the Brown Ranch, in the vicinity of the present Sahuarita High School, from "old lumber and packing, whatever they could get." No trace of that building remains. Philip Goorian collection.

SAHUARITA COMMUNITY CENTER. This building served for many years as a cultural, administration, and religious events center in old Sahuarita. It remains sound and is still in use. Photo taken in 2002. Philip Goorian collection.

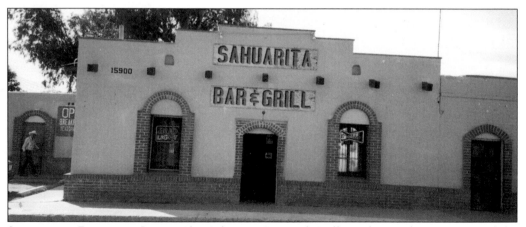

SAHUARITA BAR AND GRILL. The Sahuarita Bar and Grill on the northwest corner of the Nogales Highway and Sahuarita Road, and its neighbor, the One Stop Shop, formed the heart of Sahuarita commerce from the late 1880s. This building, four miles north of the present Green Valley, was a general grocery and restaurant, owned by Mr. Harry Manelus, a Greek national with a Spanish wife from Nogales. Mr. Manelus bought land and built a grocery store and restaurant. As lately as 1943 the building sign read "Sahuarito", but was repainted "Sahuarita". Residents, Anglo and Hispanic, did their grocery shopping at "the Greek," who credited families until payday. In 1949 Manelus obtained a liquor license and opened a bar in the building. Some residents recall, as children, peeking under the swinging door between the grocery and the bar, to stare at the boots of cowboys lined up for a drink. In 1959 Mrs. Mary Manelus closed the grocery but retained the bar and restaurant, and converted a three-room attachment into the bar area. The area was also known as "Cotton Camps." Credit Dr. Dick Grabowski, Philip Goorian collection.

ONE STOP MARKET. The One Stop Market, erected before 1915 on the southwest corner of Sahuarita Road and Old Nogales Highway was originally the Oro Verde (Green Gold) Market. A.M. Corkin had a vegetable packing plant here, shipping broccoli under ice and other vegetables to Tucson and the nation. Vegetables were followed by cotton. When vegetable farming left, the building was named One Stop Market. About 1943, German prisoners of war picked potatoes, which local men lugged to the packing plant. The Santa Cruz riverbanks are indicated by the thick stand of riverine vegetation. The FICO pecan groves are visible west of the River and the Sierrita Mountains are far west of the ochard. On the left is the Sahuarita Post Office, an associate office built about 1975. The Territorial post office in Sahuarito closed July 11, 1886. Sahuarito residents were served from Helvetia, Twin Buttes, and Vail. Another post office opened in 1915 in One Stop, but ran spasmodically, due to the shortage of postmasters. Residents were served by Twin Buttes, Continental, and the Southern Pacific Railroad Station. Credit Dr. Dick Grabowski, Sahuarita Times and *Green Valley News & Sun*.

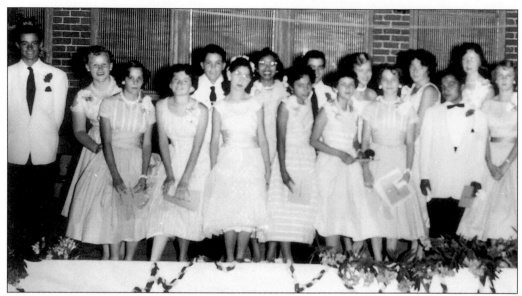

GRADUATION. The class of 1958 was the last to graduate from the old Sahuarita School. They built a small stage on the south side of the school and decorated it with local oleander. All the girls wore long skirts and the boys wore white formal jackets. Pictured, from left to right, are Ruben Federico, Barbara Brown (Bennett), Judy Fox, Hartley twins, Jesus (Junior) Felix, Celia Felix, Mary Translavania, Mary Estrada, Danny Stewart, Yvonne Carrasco, Barbara Denton, Lana Harris, Hartley twin, Frank Soto, Sharon Davis, and Sutah Thomas. Courtesy Barbara Bennet.

GRADUATES. Years after the fact, 13 Sahuarita High School alumni, from 1948 to 1968, met to exchange reminiscences. Pictured on the left, standing, are Earnest Camacho, Cruz Fisher, Olga Gonzalez, Juan Ortega, Dolores Felix, Georgina Mirande, David Garcia, William Vega, Alberto (Chito) Vazquez, and his wife Juanita Vasquez. Kneeling are Margaret Gonzalez, Virginia Estrata, and Guilliama Cano. Courtesy María Ortega Bañuelos and Arizona Historical Society.

SISTERS IN SAHUARITA. This photograph was taken February 13, 1953, by Sister Mary Grace Stelly of Sister Savoi, left, who holds a First Communion class. Sisters of the Mission Servants of the Most Holy Eucharist came down by train from Tucson, to hold catechism class in Sahuarita and Continental. They set up tables outside the schoolhouse and the Farm Bureau in the 1940s and 1950s. The sisters lived in the Pio Decimo Convent, part of St. Johns Parish in southwest Tucson. Courtesy Arizona Historical Society and Diocese of Tucson.

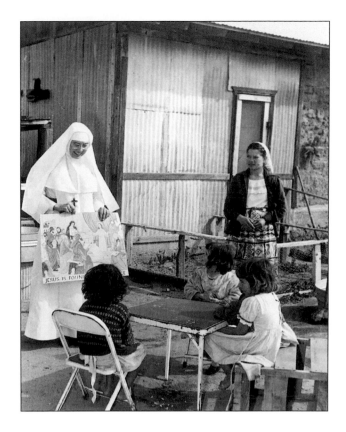

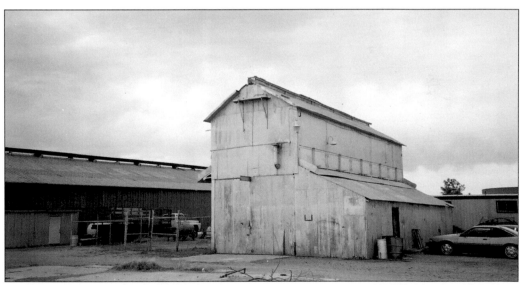

COTTON GIN. Finis Brown Sr. built this metal-sided cotton gin at Sahuarita. It still stands, recognizable but shuttered and defunct. Unlike so many others, this gin was never dissembled and hauled away. The broad cotton fields are gone, largely replaced by pecan groves and new residential neighborhoods. Only the skeletal building remains. Philip Goorian collection.

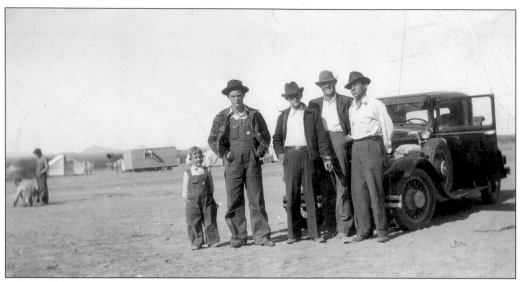

OFF TO OKLAHOMA. Arizona pioneers Orval and Bobby Brown, originally from Oklahoma, set off to Oklahoma about 1951, to fetch Orval's bride. Orval married RichardeenYork and brought her back to Sahuarita. The families farmed lettuce, broccoli, and other vegetables, which gave way to cotton. Note the tent and a house in the background. Courtesy Barbara Bennett.

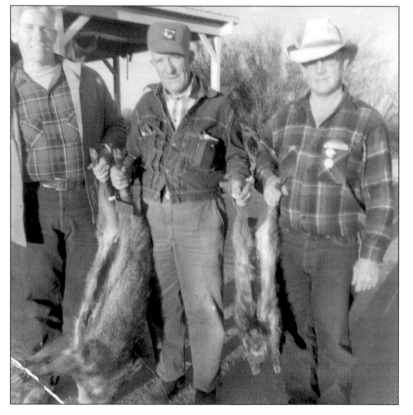

HUNTERS. In 1965, Sahuaritans Edward Brown, Mr. Johnson, and Orval Brown called themselves "The Great Hunters" as they proudly display the gutted carcasses of a pair of wild javelinas. The animal resembles a hog but actually is a type of rodent. This area is prime javelina habitat. Courtesy Barbara Bennett.

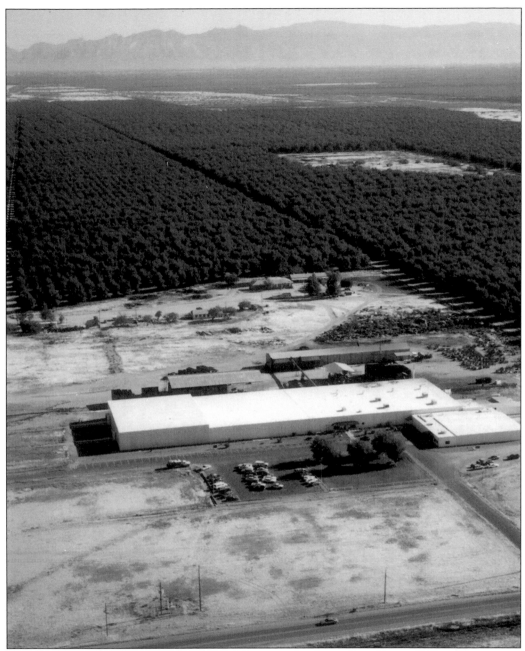

PECANS. Since the very beginning, FICO has put the "green" in Green Valley. This spring picture shows some of the 12,000 acres of orchard and the processing plant. Hundreds of acres of young trees are added most years. Pecans have supplanted cotton, grain, and vegetable crops. To the rear of the plant, the old brick Sahuarita schoolhouse and the principal's house, c. 1900s, lie between the plant and the groves. The clearing around Mission Church San Martin de los Porres is on South Santa Rita Road. The Sahuarita Road, running east and west to the corners, is immediately beyond, pictured right center. Pecans have been an important local industry, providing employment, exports and culinary treats since 1965. FICO has the largest irrigated pecan orchard in the U.S. Courtesy Farmers Investment Company.

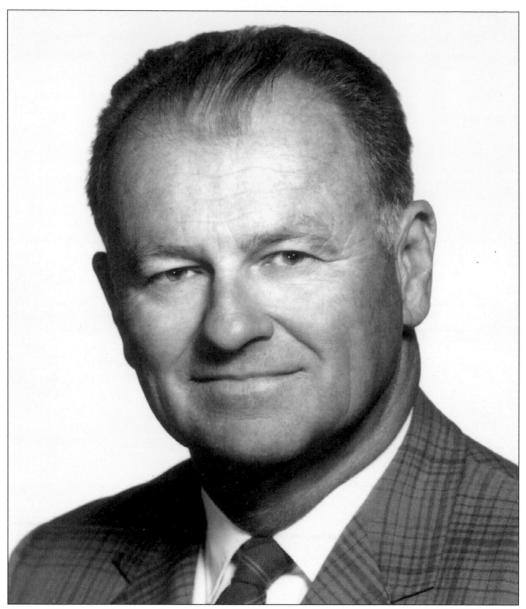

KEITH WALDEN. This is a photo of Keith Walden, agricultural entrepreneur, 1913–2002, taken about 1958–60. Walden, California-born into a banking family, put himself through school during the Depression. He and Henry Crown of Crown-Zellerbach established FICO in 1942 with Walden as chairman. FICO harvested its first cotton crop in 1948, doubled the planting in 1952, rotated cotton with barley and corn, and experimented with Spanish peanuts, vegetables, and wine grapes. At one time FICO was the largest lettuce grower and shipper in the U.S. In 1952, Walden built the Continental Feedlot, which fed 20,000 head of cattle but closed in 1976 under a barrage of complaints about odor from the new community of Green Valley. Waldon sold the Maxon brothers 2,900 acres of FICO land to build the new retirement community of Green Valley, donated land to build San Martin de Porres for the Haven Golf Club and Haven County Club, and established the pecan groves in 1965 as Green Valley was getting under way. Credit Sanders-Manley Studios, Courtesy Farmers Investment Company.

Six

RANCHES

In 1820, ranchers Ignacio and Tomas Ortiz, brothers, petitioned Sonora and Sinaloa Provinces, New Spain, for San Ignacio de la Canoa, on the old Baca Float. Canoa was ranched during the Mexican period, which ended in 1854, and Territorial period. Anglo pioneers and partners Frederick Driscoll and Thomas Maish purchased the grant in 1876. In 1912, Levi Manning bought the property, and in 1916 sold the northern portion to the Intercontinental Rubber Company. On a 100,000-acre spread, the Mannings—father, son, and grandson—created the agricultural heyday of the Canoa Ranch, with 10 working families, 35 to 40 cowboys, large barns, sheds, corrals, and a school. Today Canoa faces residential development, but the old Manning buildings are being considered for historical preservation.

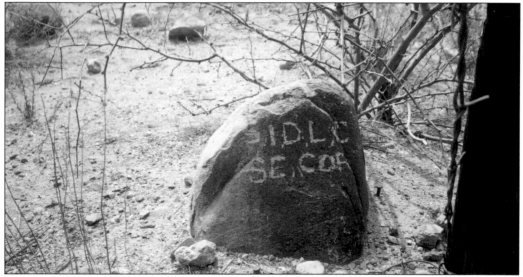

SURVEY. In 1820, the Ortiz brothers petitioned New Spain for four sitios, 17,352 acres, on San Ignacio de la Canoa. Elias Gonzalez surveyed the Canoa Ranch on July 10 and 11, 1821. He used the Spanish vara, a twisted rope 32 inches long, and inscribed survey points with long poles onto *El Camino Real*, then a well-traveled Spanish military road and the first highway between Tucson, San Xavier del Bac, and Tubac. Gonzales described the Santa Cruz River Valley as "an area that contains a wide plain, through the middle of which runs the river of this military post, although without water . . . containing mesquites, china trees, tamarisks, palo verdes, giant (saguaro) cactus, and a few cottonwoods and willows." His description is recognizable today. The 1880 Harris survey and the 1990 Contzen survey confirmed the original survey. Contzen marked every half-mile with wooden stakes, and left survey stones at the four corners of the ranch. The southeast cornerstone, nailed to the ground, still reads clearly, "S.I.D.L.C. SE Cor." (San Ignacio de la Canoa, southeast corner). Philip Goorian collection.

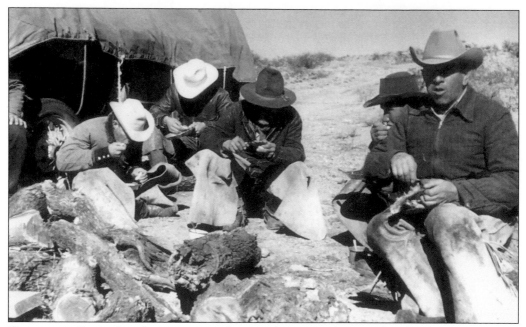

VAQUEROS. Canoa Ranch vaqueros, working cowboys, stop for a meal at the chuckwagon. The language is Spanish. The food is cooked over mesquite trunk sections. The men wear typical range attire for the 1940s and '50s, sombreros, Levi jackets, and chaps. Many descend from families living in the Gadsden Purchase before it became part of the U.S. and of Arizona. Courtesy Deezy Manning-Catron, Canoa Ranch.

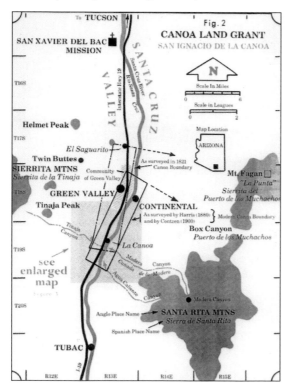

MAP. This updated Canoa Land Grant map shows the territory from Tubac to San Xavier del Bac. It includes the farming villages of El Saguarito, currently Sahuarita, the site of the future community of Green Valley, and Continental, all within Canoa territory. The hatched area eventually became Green Valley. Courtesy Deezy Manning-Catron, Canoa Ranch.

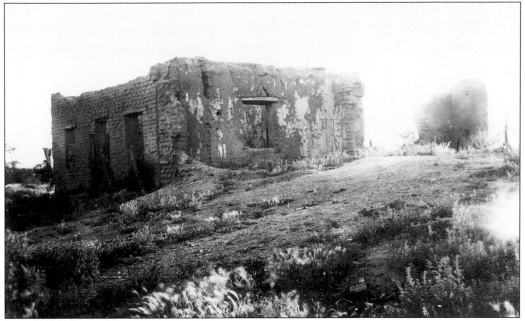

CROSS ROAD TAVERN. The *Weekly Arizonian*, September 15, 1859, trumpeted: "NOTICE. The subscriber having opened a Hotel at the Conoa (sic) Ranch, calls the attention of his traveling public to his new House 'The Cross Road Tavern.' Every attention will be paid to the comfort of Travelers, who will find a good table and the best liqueurs the market affords..." Richard M. Does, Canoa Ranch. The 1915 photograph shows the tavern a dilapidated ruin. No trace remains and its exact location is unknown. Courtesy Arizona Historical Society.

EARLY RANCH SCENE. The McGees took an option on Canoa Ranch the same year Levi Manning purchased the ranch. In this 1912 photo, Al Harris sits in the wagon on the left. The McGees dropped the option and stayed on the McGee Ranch where most are today. Canoa was Manning family property for three generations. Courtesy Lynn Harris, historian, McGee Ranch Settlement.

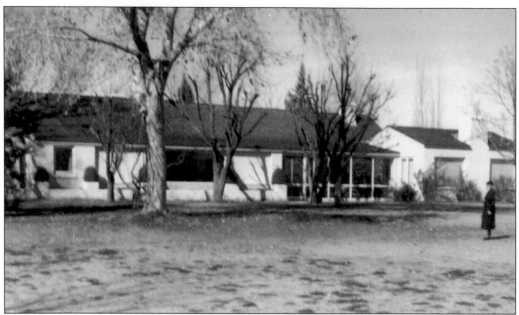

MAIN HOUSE. This is the main house in December, 1940. Mrs. Crim is on the right. A 1958 visitor described the Manning headquarters, then the social hub of the southern Santa Cruz Valley. He dutifully noted white and gold fireplaces, pale gray-blue walls, gray beige carpeting, Fortunay chairs covered with off-white raw silk, a couch upholstered in deep blue and gold, and Venetian glass lamps, and gold beige draperies from Japan. The sunken living room had hardwood maple floors and a marble fireplace. Courtesy Deezy Manning-Catron, Canoa Ranch.

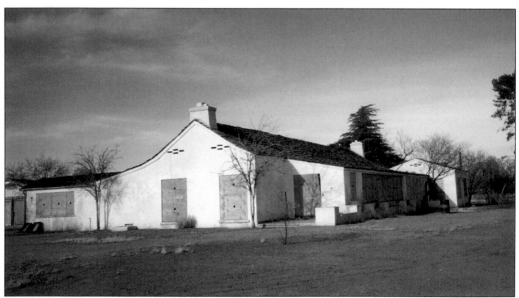

MAIN HOUSE, REVISITED. A high wire mesh fence protects the perimeters, and all windows and doors are boarded. This building and others in the headquarters area were falling prey to the elements and to uninvited visitors. They are listed on the Arizona State Inventory of Historic Places, in cooperation with Pima County and the Smithsonian Institution. Philip Goorian collection.

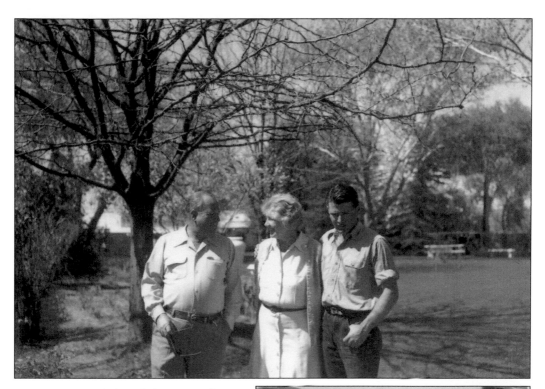

FAMILY. Pictured, from left, is Howell Manning Sr., Bert Lewis, the mother of Deezy Manning and Howell Manning Jr., on the Canoa Ranch in 1950. The open, tree-lined square between the main houses and the Santa Cruz River, invites a moment's cool relaxation. At its height, Canoa had 10 working families, many cowboys, a forge, large barns, sheds, corrals, and a school. Courtesy Deezy Manning-Catron, Canoa Ranch.

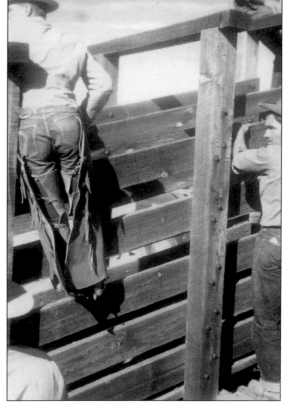

THE BOSS. Howell Manning, left in the picture, in full Western regalia, climbs onto the loading chute. The cowboy to the right is Raul N. Grijalva, father of Raul Grijalva, United States Congressman from southern Arizona. From here the cattle will be separated, some for market or breeding, while others, old bulls and cows, steers and heifers, go off to market. Courtesy Deezy Manning-Catron, Canoa Ranch.

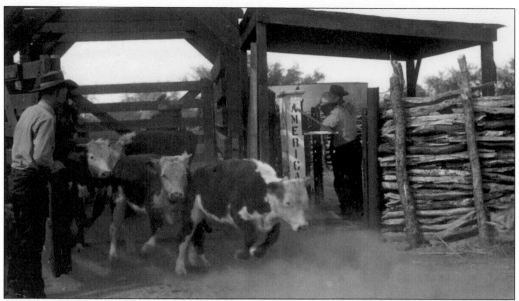

CATTLE BREEDING. In 1917, Howell Manning fenced the open range into large enclosures to rotate pasture, and introduced registered Hereford whitefaced bulls and Arabian horses. A group of whitefaces, desperate for their freedom, boils out of the holding corral through the chute. At left, Foreman Maynard checks each animal as it passes, while Howell "Big" Manning weighs them on an "America" scale, c. 1930–1940. Cattle expert Catron McTavish reported in 1925, "no finer specimens are anywhere produced in the U.S." Courtesy Deezy Manning-Catron, Canoa Ranch.

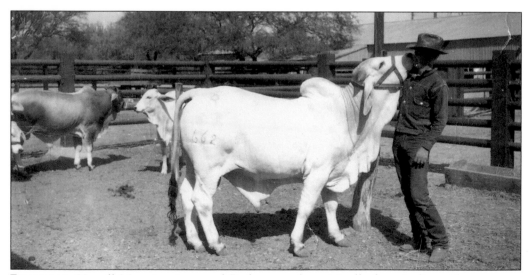

BRAHMAS. Howell Manning imported Brahma cattle, originally from India, with enormous dewlaps and a hump on the neck. The animals are adapted to extremes of heat, flies, and ticks. Here a Brahma bull nuzzles a cowboy, next to a sturdy corral with metal bars on rail cross-members. Water tank and electricity poles are in the right background. Mixed Hereford-Angus crosses have replaced Brahmas and purebreds. "They travel better," says a modern-day rancher. Now the cattle are being removed from the ranch, in advance of development. Courtesy Deezy Manning-Catron, Canoa Ranch.

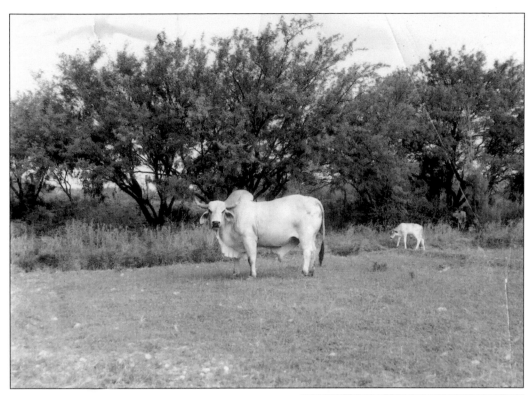

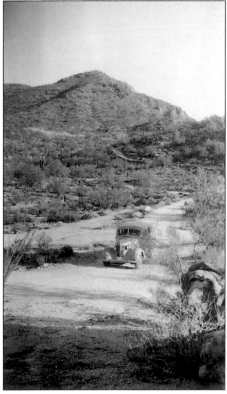

BIG BULL. An enormous Brahma bull obligingly poses for the camera. One of his numerous offspring stands to the side. The size of the mesquite trees and the flowing riverine grass tell that the Santa Cruz River is nearby. Courtesy Deezy Manning-Catron, Canoa Ranch.

FORDING THE RIVER. A 1938–1939 Chevrolet fords the Santa Cruz River near Canoa. Vehicles could pass easily in normal flow; when floods struck the motorist waited or risked being swept downstream. Vegetation flourishes after a flood. Way off in the distance, the rural road follows the contours as it snakes its way across the countryside. Courtesy Barbara Bennett.

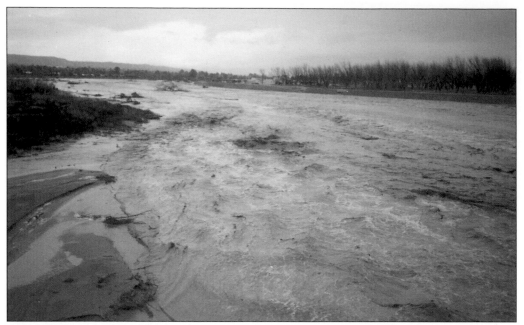

SANTA CRUZ IN FLOOD. The greatest floods hit in 1967, 1978, and 1983. The 1983 flood, the most violent in a century, left thousands homeless in Sahuarita and Green Valley. Each flood left its mark in the form of uprooted trees and brush, as it rampaged downstream to Tucson and Phoenix, and eventually the Colorado Delta in Mexico. Wild Arizona revives after a flood. Philip Goorian Collection.

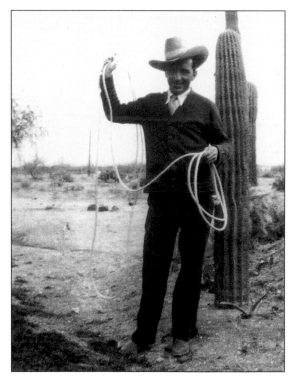

4 WINDS RANCH. Caren Peck Bogurtz of Victoria, British Columbia, wrote: "Pictures taken by my parents about 1931." About 1931, Mr. Chary Ceran in necktie, city shirt, and sweater, poses with his riata before a giant saguaro. Mr. Caren sold the 4 Winds Ranch, on the east bank of the Santa Cruz River, to Mr. A.T. West, who sold to Douglas and Frances Luger. Many active and extant ranches dot the area. Courtesy Tubac Historical Society.

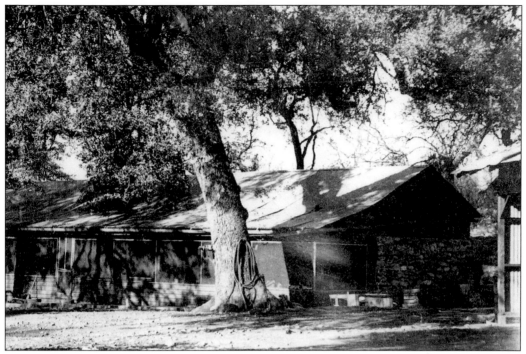

HEADQUARTERS. This picture shows the home at the 4 Winds ranch. Large cottonwood trees and a screened porch moderated the hot summer weather. A sloping roof carried off the summer monsoon rains. A very hard-working place, water was crucial to 4 Winds' survival. Courtesy Tubac Historical Society.

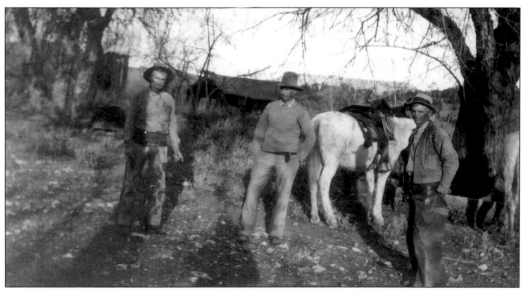

RANCH HANDS. Pictured, left to right, are Mr. Kearns, Mr. Steele, and Mr. Burnett, posing under a large mesquite tree on a cool winters' day. Steele wears a 10-gallon hat, while the others favor Stetsons. An outhouse on the left and the ranch house in the center background dispel thoughts of the romantic "Old West." The mesquite trees are brown as the great drought of the 1920s and '30s commences and deepens. Courtesy Tubac Historical Society.

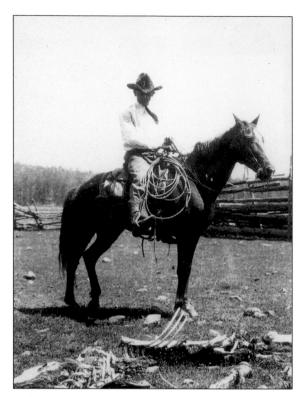

THIRST. Cattle bones bear mute testimony to tough ranching times, during prolonged drought. Bones made a miserable cash crop, to be sold and hauled away. The mounted cowboy, who probably has seen all this before, is fully equipped with a long riata, spurs, and a Western saddle. Part of the fence behind is collapsing to the ground. Courtesy Tubac Historical Society.

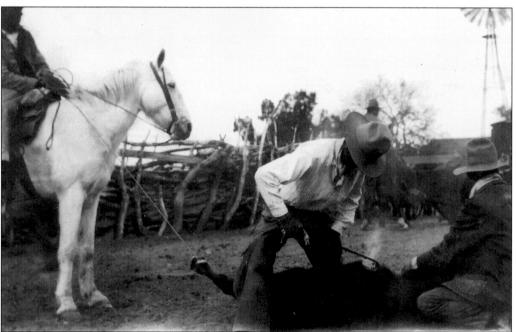

BRANDING. Pressing metal to flesh. One cowboy holds the animal's head down. Another mounted cowboy, who has lassoed the steer around its hoof, waits to drive the critter back to the herd and his mother. Then he will lasso another. The windmill vanes, right rear, are in motion to bring stock water from a well to the tank. Courtesy Tubac Historical Society.

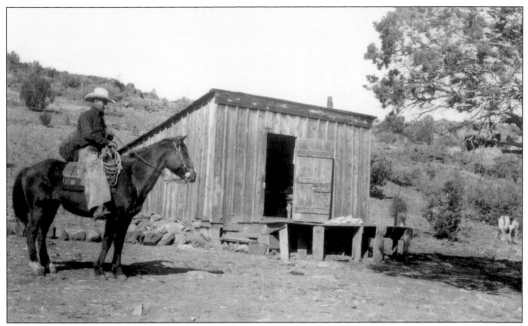

LINE RIDIN.' This cowboy is on his horse before a line cabin and a large tree. Cowboys spent nights here when they repaired the long miles of barbed wire fence. Their bedrolls came in very handy, and their blanket broke the chill of winter nights. Fleas and chiggers were another question. Courtesy Tubac Historical Society.

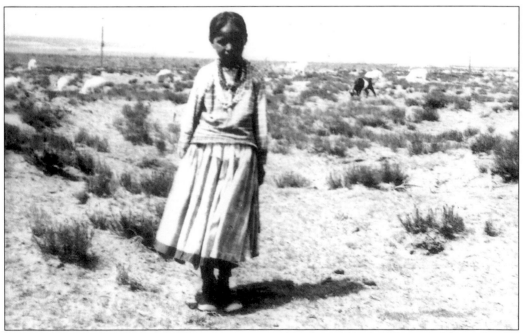

PAPAGO. An unidentified young Papago servant girl is shown here working and living at the ranch. She wears a combination of tribal and Western clothing, and casts a small shadow on the dry, almost boundless land. The Papago Reservation is miles north. Courtesy Tubac Historical Society.

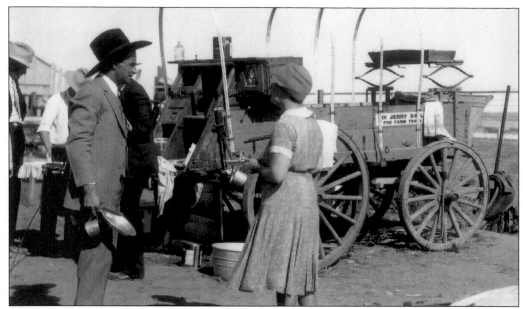

DRUMMER. Itinerant drummer Lee Jerry, bronzed and very impressive in his city suit, visits 4 Winds. His last name is partially covered by a towel hung from a wagon hoop and he has loaded his wagon with farm and home tools. He holds a pot and a pan in one hand to interest the ranch wife. She and three men express curiosity at the goods. A tin can perches on a cabinet in the rear of the wagon. Courtesy Tubac Historical Society.

TINAJA RANCH. Young Ann Manning, daughter of Howell Manning Jr. and Pancho Bodilla pose at the wooden fences of the Tinaja (stock tank). Tinaja was a station on the Canoa Ranch. The Tinaja is west of the Canoa Ranch and Green Valley, and north of Tinaja Peak, as shown on the Canoa map. The bone-dry Tinaja, Demetrie (Amado), and Esperanza *arroyos* lead east through Green Valley to the Santa Cruz River, and the Escondido *arroyo* runs through Canoa Ranch to the river. Courtesy Deezy Manning-Catron, Canoa Ranch.

KENYON RANCH. In the 1920s, Otto Kinsley established the Kenyon Ranch, west of the Santa Cruz River, to entertain guests on 1,000 acres of rolling hills west of Tubac. This is very different ranching. The rustic welcoming sign, hung high to catch the eye and the breeze, ushered in the dudes. The sturdy gate with barbed wire running on both sides welcomed people and kept cattle from roaming. William and Marcella (Sis) Allen owned and operated the ranch from 1939 to 1975. Courtesy Alan Manley, Tubac Historical Society.

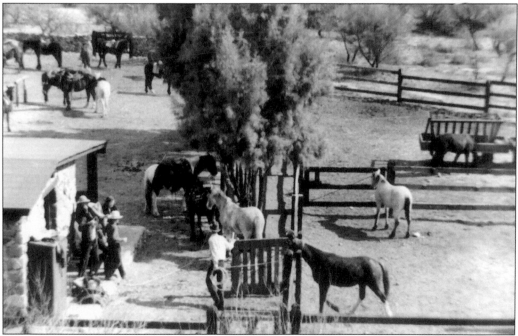

THE OLD WEST. An unsurpassed 1943 view of Kenyon Ranch headquarters, with guest cabins and outbuildings, horse corral, hay rack, functioning windmill, ramada, and horseshoe pitch. A chuckwagon and three cowboys worked all day. Trails led off in all directions and guests could forge for themselves. A tenderfoot might encounter javelinas, coyotes, and birds, and an occasional rattlesnake. Bears and bobcats shared the terrain. Courtesy Alan Manley, Tubac Historical Society.

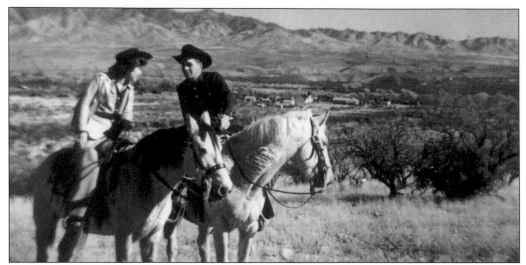

HORSEBACK. A man and woman share a quiet horseback chat at the Kenyon Ranch, in a classic Western scene. The west bed of the Santa Cruz River, the Ranch, and the Tumacacori Mountains form the background. Mesquite trees dot the land between short grass and rock rubble. Courtesy Alan Manley, Tubac Historical Society.

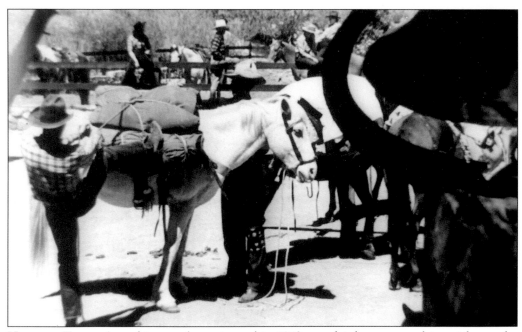

HIT THE TRAIL. A working cowboy, pictured in 1943, uses his knee to put his weight on the packhorse's flank. He intends to cinch the belt so tightly that the pack will not fall off during the ride towards the Tumacacoris. When the string returns to the ranch, the dinner bell, right foreground, is ready. Courtesy Alan Manley, Tubac Historical Society.

Seven

RANCH SETTLEMENT

The McGee Ranch Settlement, 4,800 feet high and dry in the Sierrita hills west of Green Valley, dates to 1895, when gold seekers James Riley McGee, David Lively, George Harris, and their families traveled west by wagon train towards California. When a wagon wheel broke down at Chigger Hill, they stopped to repair the wheel and pan for gold. In 1898 they settled a permanent camp, predating Arizona statehood. Three years later, a prospector guided them to an abandoned ranch where an English homesteader left a fireplace, a rock sheep and goat corral, fig and apricot trees, grape, bean, and "squaw corn" fields. The Settlement continues there today.

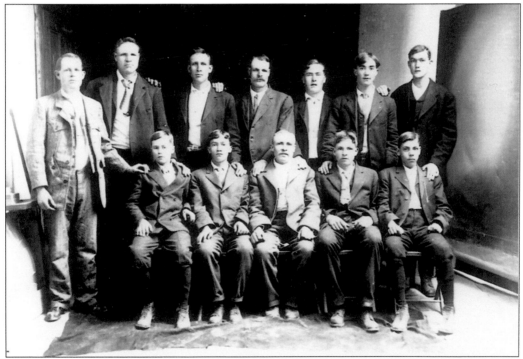

McGee Men. "Eligible McGee bachelors", about 1913 are, from left to right: (standing, back row) Andrew Harris, Bill Harris, Dan Harris, Fred Harris, Matt McGee, Rero (Robert) McGee, and Arthur Lively; (seated) Napoleon "Empy" McGee, then a 12-year old boy, Almo (Shorty) McGee, (Little) David Harris, Fawnzo Harris, and Marone (Blackie) Harris. Most family names survive today and many new names have been added. Today, 250 to 300 family members, grandchildren, great-grandchildren and even great-greats call McGee Ranch home. Courtesy Lynn Harris, historian, McGee Ranch Settlement.

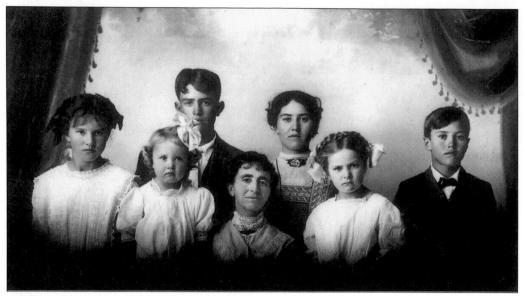

FAMILY. Pictured are the McGees about 1909 or 1910. Left to right are: (in the background) Robert and Mirma; (front) Lura, Janet, Florence McGee (mother), Myrtle, and Napoleon (Empy) McGee. The original name was the Rero Ranch, which changed during the early 1930s when many McGees returned to homestead. Courtesy Lynn Harris, historian, McGee Ranch Settlement.

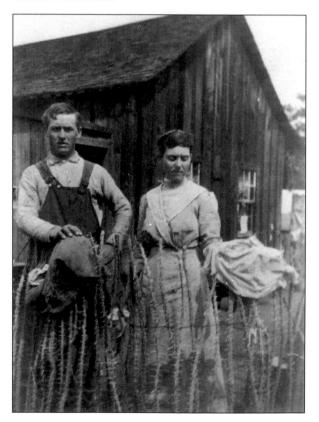

BROTHER AND SISTER. Matt McGee and his sister Mirma McGee are on the McGee Ranch, c. 1909. Behind them is one of the homes. In front a living ocotillo fence is strung together with wire to keep the varmints out. They dress as any down-to-earth pioneer family in America. Work was hard but the Settlement survived, and continues to thrive. Courtesy Lynn Harris, historian, McGee Ranch Settlement.

HARRIS. Life on the McGee Ranch, about 1912. Florence Harris, background, and Martha Harris is with her son Bill Harris and grandson Leander Harris, son of Charles Harris. The Sierrita Mountains rise more than 5,000 feet behind, on very rough terrain. This family descends from George Harris, head of one of the family groups that traveled west by wagon train towards California and stopped at Chigger Hill. Courtesy Lynn Harris, historian, McGee Ranch Settlement.

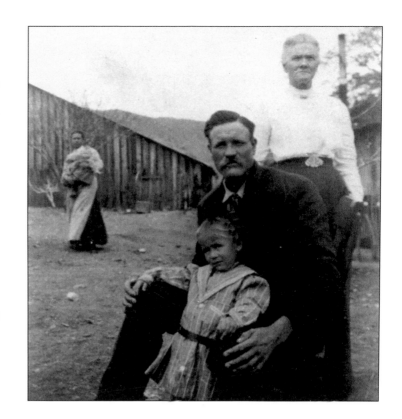

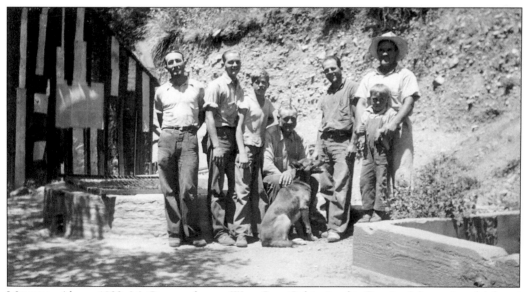

MINING. About 1933, McGees gather at West Star Cabin in the Sierrita Mountains, high on the western edge of the settlement, for an extended family photo. From left, family here are Lee Harris, Dudley Fox, Jim Bell, Bill Harris, Luther Harris, Chad McGee, and Keith McGee. The Settlement holds mining claims, but is not active. Courtesy Lynn Harris, historian, McGee Ranch Settlement.

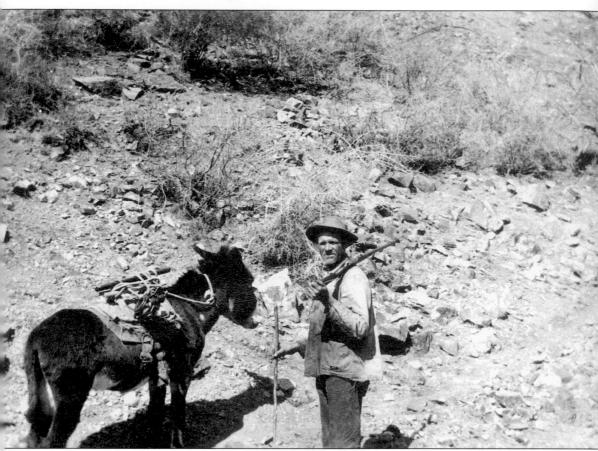

PROSPECTOR BILL. Bill Harris, c. 1938, is shown working in the Sierrita Mountains. His burro's name is Chubby. Bill was a gold seeker all his life, but never struck it rich. He had two homes, one on the settlement and the other in a mountain cave he excavated from a gold mine. Bill kept his expenses to a minimum, with no telephone, electricity, or car, but he did have a kerosene refrigerator, a wood stove, and pegs on the walls for his clothing. He carried a 22-gauge rifle to ward off rattlesnakes and bag an occasional jackrabbit. Bill never married. The *Arizona Daily Star* described him in an interview as a "bachelor hermit," but he kept a battery-operated radio to maintain contact with the outside world. When he grew too old to live alone he moved nearer the settlement, still one-half mile away. He was the oldest son of George Harris, one of the original pioneers. Courtesy Lynn Harris, historian, McGee Ranch Settlement.

ANNIE LIVELY. Grandma Annie takes time to pose for a snapshot with her daughter Urie Harris, about 1925. Their car climbed the steep McGee Road to reach the settlement. Beyond the settlement and up into the heights hardier vehicles are required. Courtesy Lynn Harris, historian, McGee Ranch Settlement.

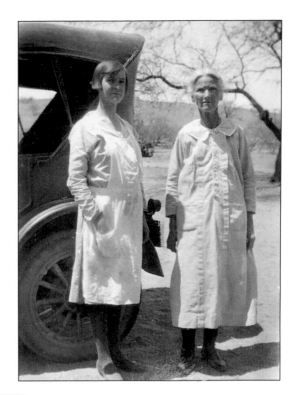

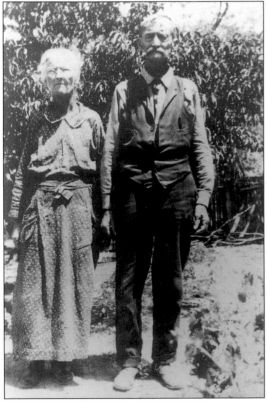

LIVELY'S. Pictured are Annie Lively (Grandma Annie), left, and David (Grandpa Dave), c. 1930. The Lively name has vanished, but the original Harris, McGee, and many others continue. The original four families dwindled to three in the Great Depression and increased to 13 in 1952. Today, the settlement has almost 300 family members. Their homes line the streets carved onto the old Englishman's bean fields. Courtesy Lynn Harris, historian, McGee Ranch Settlement.

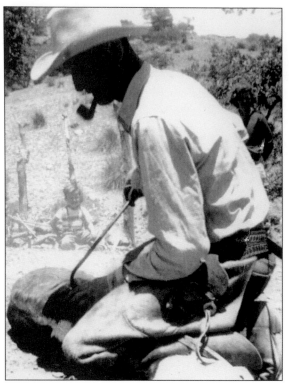

ARTHUR LIVELY. Arthur Lively shows how to brand a steer. A young boy watches from the sidelines. In spring and fall McGee Ranch men and older boys ride into the hills and canyons and drive the herd downslope to the Ox Frame Corral. There they inoculate new calves, notch ears, castrate, and brand young males "H bar L." An early family wife selected this name for husband Leander Harris. Courtesy Lynn Harris, historian, McGee Ranch Settlement.

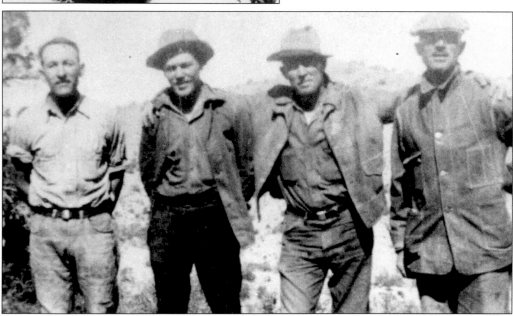

HARD WORKERS. Left to right, *c.* 1946, are Leander Harris, Louie McGee, Earl Nolen, and Robert McGee. These men seemed ready for any work that came their way, from gold mining, cowboys and ranching, and farming and construction. The McGees say: "We avoid cities as much as possible. We are a preferred contractor with a very good reputation. The State of Arizona, power companies, and mining enterprises like us, and so do ranchers." Courtesy Lynn Harris, historian, McGee Ranch Settlement.

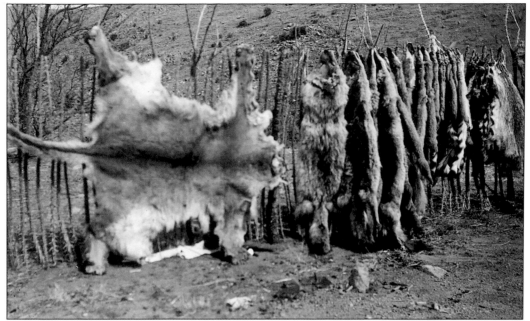

SIERRITA MOUNTAIN FURS. The large fur, left, is from a mountain lion. Coyotes are center and right, and ringtail cats (a raccoon-like cousin that dens in the mouths of deserted mines) are at right. Shooting was legal then. The Sierrita are wild Arizona. Samaniego Peak looms at 6,206 feet and Red Boy around 6,000 feet. Ravines separate the dark hills and draws; oak and thorny mesquite abound on lower elevations and manzanita above. Outsiders require permission to enter the highlands. Courtesy Lynn Harris, historian, McGee Ranch Settlement.

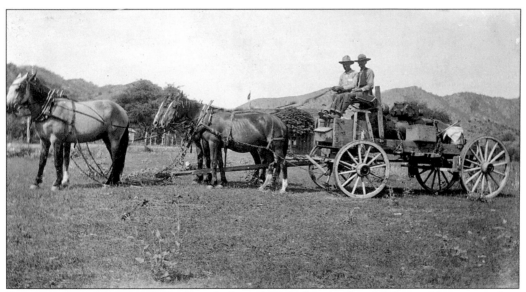

EARLY FARMING. On the McGee Ranch about 1920, before machines lightened farming work, a two-horse team wagon makes its slow way. Alma Harris, left, holds the reins, and David Lively is at the right. Courtesy Lynn Harris, historian, McGee Ranch Settlement.

COWBOY RESERVOIR. Cowboy, a large reservoir, *c.* 1945, holds water for McGee whiteface Herefords. One has ventured in, probably for a dip in the cool water. Small confluences are dammed and 50 to 60 water tanks, some concrete but most earthen, capture water for range cattle. In dry years, when the smaller tanks yawn empty and reservoirs on the best streams are dangerously low, the settlement trucks in drinking water for man and beast. Each April and October, McGee Ranch men and older boys ride into the hills and canyons, collect the cattle and drive them down slope to the Ox Frame Corral. There they separate the herd to retain or market, inoculate new calves born since the last roundup, notch ears, castrate and brand young males "H bar L." New calves are branded, earmarked and vaccinated, then reunited with their mothers and released for another six months in the wild. The weaned calves are held several days, then shipped to market. Heifers and steers, old and barren cows, and old bulls are driven to the main ranch for slaughter, or sold to feedlots for fattening. Courtesy Lynn Harris, historian, McGee Ranch Settlement.

WAGON WHEELS. None of these are the wagon wheel that broke down at Chigger Hill, but any could be. After the pioneers fitted new spokes to the wheel, they prospected for placer gold, lassoed wild cattle, churned butter, made cheese, and harvested wild honey. They traded for flour and coffee in nearby Twin Buttes and in Nogales, which was three days away by horse and muleback. Philip Goorian collection.

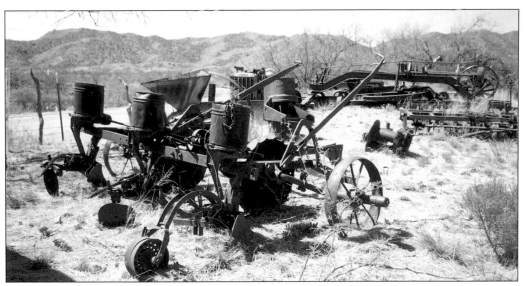

PLANTER. Fields were plowed and harrowed, then seeded with this three-row, three-hopper planter. A horse-driven team pulled the planter, which opened the rows, dropped and covered the bean or corn seed, and tamped the soil down. This machine is thought to be made in the 1850s, old in the earliest days of the McGee Settlement. The McGees dry-farmed their land for 40 years. The fields have been converted to housing and machinery shops and yards. Philip Goorian collection.

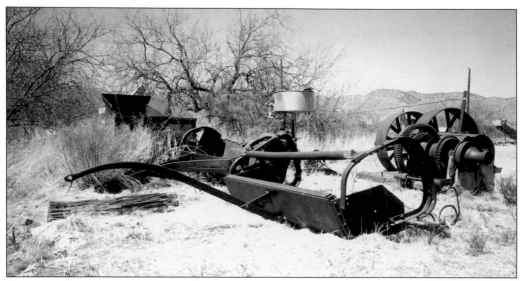

Scraper. This road scraper is another piece of antiquated machinery, dating about 1900, when horses and mules provided traction power. A man steered the two-horse teams from the rear. The privately maintained McGee Road, four miles west off Mission Road, needed to be scraped after rains. These machines are photographed in the McGee "boneyard," an early-day farming museum, with the shadow of the Sierritas looming in the background. Philip Goorian collection.

Grand Old Man. Leander "Lee" Harris, son of Charlie Harris, is the oldest resident in the Settlement. Lee tends the grave of Erero McGee in the McGee family cemetery. Erero was born in 1898, at the time of the original settlement, and died young in 1910. Lee, who admits to 93 years, has no intention of "retiring." Philip Goorian collection.

CONSTRUCTION. The McGees fitted up this old Caterpillar tractor with a blade, but said it did not work very well. The Cat, with tread but no wheels, was manufactured about 1930 in Peoria, Illinois. The McGees entered construction early. The first joint operations were in 1903, hauling supplies to Helvetia Mine and ore from Helvetia Mine, twelve rugged miles east of Continental. They built the Twin Buttes Road to the mine in 1906 and the Southern Pacific road-bed through the Santa Cruz River Valley. After the Second World War, the partnership purchased a government-surplus bulldozer and expanded its "primitive" construction. Operating from a modest office and a large construction yard, they built difficult, high profile jobs on rugged topography. Their work includes roads throughout rural Pima County; the first hotel in Rocky Point, Sonora; high tech observatory and astronomer dormitories on Mt. Hopkins; a private observatory near Washington Camp; and a "listening ear" at the Kitt Peak National Observatory. They practice "invisible" construction, leaving no scars on the land. Philip Goorian collection.

EMPY. Napoleon "Empy" McGee, 1901–1973, was given the name of the French emperor. He owned most of the territory of the McGee Ranch. Shortly before his death he sold his holdings to the Sierrita Mining & Ranching (SMR), who consolidated the property under that title. McGee Ranch has a ranch and a construction company, streets, roads, and homes. Courtesy Lynn Harris, historian, McGee Ranch Settlement.

FATHER. James Riley McGee, "father," was born on April 20, 1842, one of the original founders. His remains rest under artificial flowers, drought-resistant day lilies, and mesquite trees in the spacious McGee cemetery, just west of the community. Philip Goorian collection.

Eight

Mines, Miners, and Mining

Pima County, including the Green Valley area, was well known in the mining world of the late 19th and early 20th centuries. The names of Twin Buttes, Copper Glance, Helvetia, and many others were famous throughout the U.S. and the mining world. Headframes, loaders, water towers, mills, smelters, and railroads create classic scenes of early mining operations. Mining shacks and whole towns seemed to burst from the earth, and disappear almost as quickly. Today mining ghost towns strew the area.

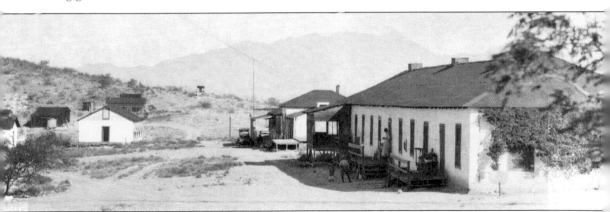

TWIN BUTTES. This is a partial view of Twin Buttes town in 1915. The large white building in the center background was the assay office, indispensable to any mining operation. Early Twin Butte assays were extremely high, running from 30 to 40 percent copper. On the right is a miner's bunkhouse, where workers could sleep between shifts. A crude road and *arroyo* separated the Anglo and Mexican communities. The *Twin Buttes Times*, issue July 1905, pronounced it "a Beautiful and Delightful Place" and boasted that the camp was higher and cooler than Tucson. Camp rules were published in two languages, but the pay scale was tipped in favor of the Anglos. Brown's Ranch in Sahuarito provided fresh meat daily, and Eastern visitors, speculators, and investors arrived for rides on the Twin Buttes railroad and examination of the mining property. Courtesy Michael Kalt III.

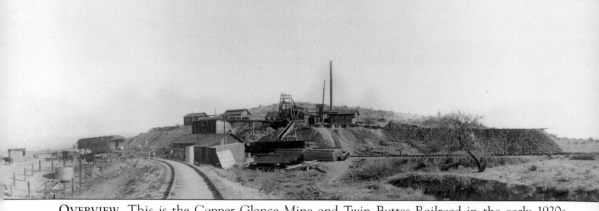

OVERVIEW. This is the Copper Glance Mine and Twin Buttes Railroad in the early 1920s. Pictured, left to right, are a desert cattle pasture, the mine car Eastern visitors rode on the Twin Buttes Railroad track, mining houses, headframe, shaft entrance and ore cars, two-stack smelter, screener and crusher, and the small track for ore cars. The desert resumed on the right. Copper mining started at Twin Buttes Mine about 1870, succeeded by the Twin Buttes Mining and Smelting Company in 1903, under president David S. Rose, mayor of Wisconsin, Wisconsin. The company sunk the first deep shafts, and completed the Twin Buttes Railroad in 1907. Midland Copper entered in 1917. In 1965, the Anaconda Company dug the open-pit Copper Glance mine, which closed in 1983. When the ore thinned out, the property was returned to desert. After the mines closed and the camp was abandoned in 1935, the Anaconda company dug a hole and buried it. (Twin Buttes today is an enormous tailing pile, some dilapidated lumber, and a cemetery.) Courtesy Arizona Historical Society.

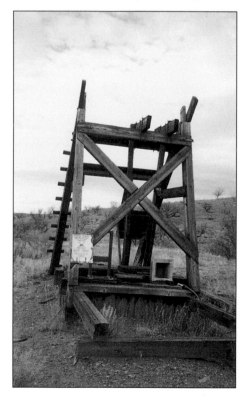

ANTIQUITY. A decrepit headframe stands over a portion of the defunct Tajo Mine, originally mined by Spaniards. The Arizona Mine Engineer warns: "Notice! Warning! *Peligro!* Shafts, tunnels, and pits are dangerous. Shafts may be several hundred feet deep, contain accretions of unexploded, noxious gases or accumulated water, and may subside or collapse without warning. Tunnels and pits can harbor enourmous snakes, and people have been killed attempting to rescue earlier victims, who may already be dead. It is an act of criminal trespass to enter real property unlawfully. Keep out." Philip Goorian collection.

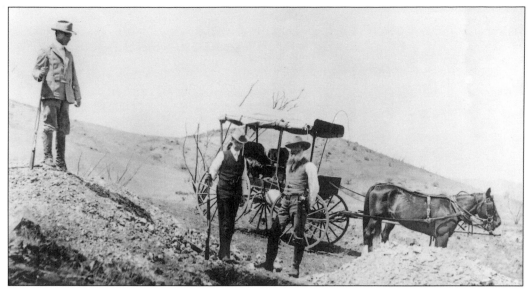

PROMOTERS. Three men in a two-horse drawn surrey were photographed in Twin Buttes, 1904. Western mines were ballyhooed in the national press as potential sources of great wealth for any person brave enough to invest. Many investors, including President Rose, were lured out West by quixotic promises. Sometimes they struck a bonanza, but most did not. The owners entertained Eastern and Midwestern visitors to Arizona Territory with rides on their ore cars and passenger car. Courtesy Michael Kalt III.

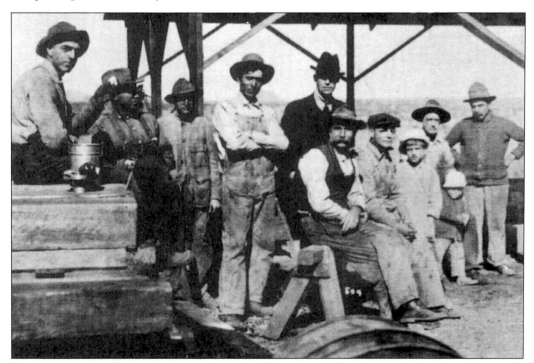

BUSINESS MINER. Ed Bush, miner, partner, and financier in business suit, posed with his work crew during a lunch break at the Minnie Mine, Twin Buttes mining district. Bush observed shortly before his death that he had outlived every man in the photo. Courtesy Michael Kalt III.

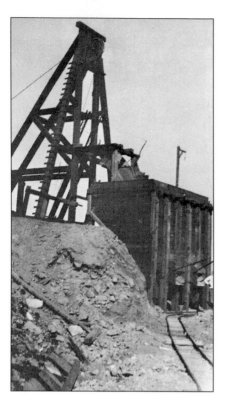

HEADFRAME. Three Mexican laborers pause for a photo at a shaft entrance to the Copper Queen Mine, one of the working properties at Twin Buttes. A headframe is built over the mineshaft, which supports the hoisting gear. The Twin Buttes headframe was A-shaped and the timbers crosscut. Cages were raised and lowered by winches for access into and out of the mine. In small mines, miners descend under the headframe by wooden trap doors, ladders, and landings down to the working level. Courtesy Michael Kalt III.

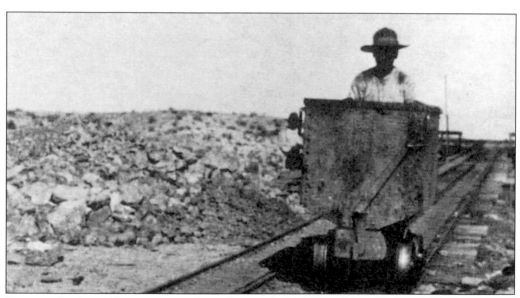

RIDING. A miner rides an ore car along the spur line of Twin Buttes Railroad. This was one of a string of cars to move ore to the smelter, and move back to the hopper for another load. It also provided a thrill for Eastern visitors to Arizona Territory. Courtesy Michael Kalt III.

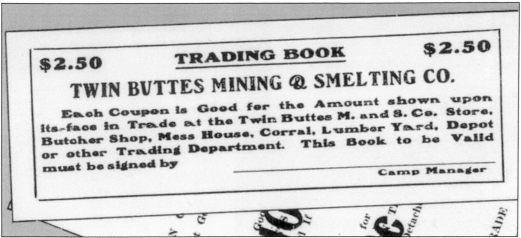

BOLETOS. Miners were paid in coupons, or *boletos*, typically 10¢ and $2.50 trading books. They were redeemable at face value in the mercantile, butcher shop, mess house, corral, lumber yard, depot, and other trading departments, when signed by the camp manager. A schedule of craft wages published April 1, 1907 demonstrates the commonplace discrimination of the times. "White" machine men earned $4 for an eight-hour day while Mexicans, many native to the area, made $2.75 for the same work; white shaft men $4.75, Mexicans, $3.00. Courtesy Michael Kalt III.

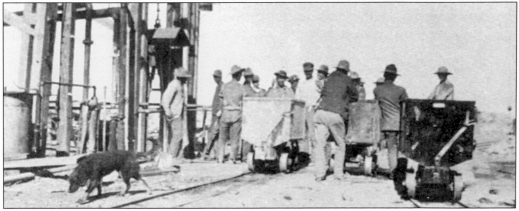

WORK SHIFT. A work shift waits for a cage to take them down to a shaft in the Twin Buttes Mine, while a faithful dog waits for his master to return. Down below, work was long and hard. The workers drilled with heavy chisels and used dynamite for explosives. Miners wore straw hats, not helmets or hard hats. Accidents were common, and death not unknown. Courtesy Michael Kalt III.

TWIN BUTTES CEMETERY. Only the Twin Buttes cemetery, overgrown and toppling, remains of the town and settlement. Behind locked gate and key and permission to enter, it still receives remains. It is enrolled on a State of Arizona list and may not be built over. Pedro "Pete" Revello, former resident and latter owner of the Twin Buttes town site, whose father and grandfather are buried in the cemetery, described the event in 1980. "They (Anaconda) made a hole and buried everything." Philip Goorian collection.

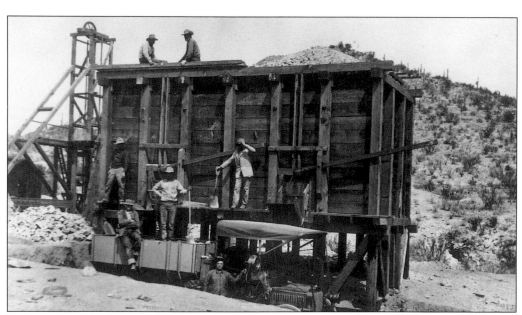

SHOVELING. Six workers pose for a photograph, so rare for workingmen at that time, at the Pioneer Mine, north and west of Green Valley off Mission Road. They will shovel the ore into the truck. From there the ore went to the smelter, or a mill. Mission Road leads north through the Tohono O'odham Nation and into Tucson. Courtesy Arizona Historical Society.

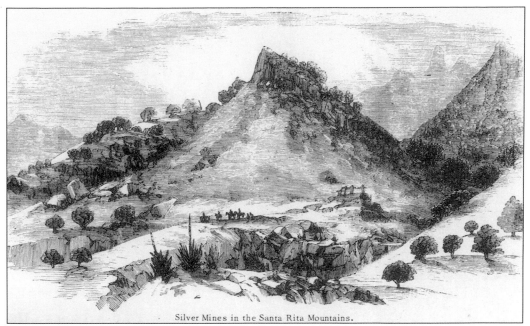

Silver Mines in the Santa Rita Mountains.

SILVER MINES. This is an idealized sketch of silver mines in the Santa Rita Mountains. A party moves away from the mines. Browne wrote, "The Santa Rita Company Mines houses have gone to ruin, and only a few adobe walls, and the frame-work for the mill remain . . . these houses, now empty and crumbling down in dusty fragments, were replete with busy life, the reduction works (smelters) were in full blast . . ." Credit J. Ross Browne, *Adventures in the Apache Country, A Tour Through Arizona and Sonora*, 1864.

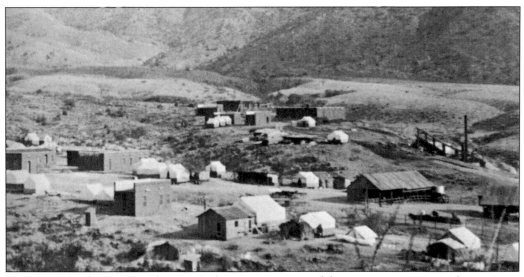

HELVETIA. In the 1880s and 1890s, Helvetia was a successful mining community, a boomtown. It reached its peak in 1895 when this photo was taken. Many miners lived in tents, others in substantial adobe or wooden homes. Today the store, mining buildings, and one-room schoolhouse have crumbled and decayed, and the U.S. Forest Service has bulldozed many of the old buildings in the once-bustling community. The towering Santa Ritas overlook only a few standing walls. Courtesy Michael Kalt III.

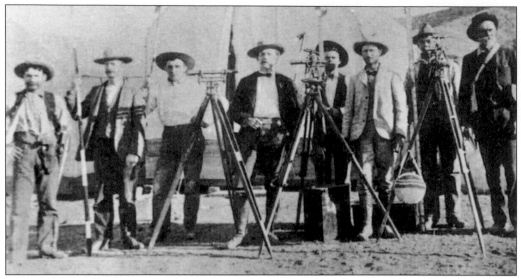

SURVEYORS. Pictured is an early survey party, with survey transits and striped sticks, at the Helvetia Mining District. The tents seen in the background served as living and working quarters. Helvetia was one of the richest and most successful Western copper mines, plus smaller yields of lead and zinc. Helvetia, a name meaning Switzerland, is in the Santa Rita Mountains, near Mts. Wrightson and Hopkins. It lies at the notch known as "Gunsight Pass," visible from Green Valley. Courtesy Michael Kalt III.

LOOKOUT CABIN. An unidentified man stands atop Mt. Baldy (Wrightson), the mountain chain overlooking the Santa Cruz River Valley. Another man kneels in the foreground, possibly scraping rocks or cleaning the cabin floor. The windows in the cabin have been smashed. Courtesy Arizona Historical Society.

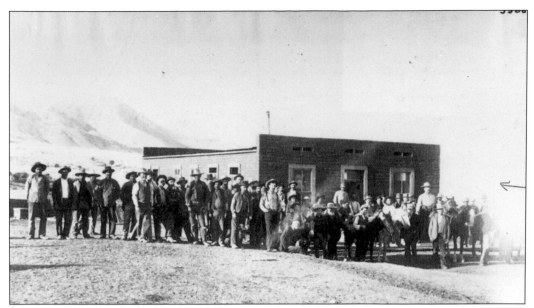

MINERS. Some 40 hard-working Helvetia miners and 2 horses assemble for a group photo in July 1901, in front of the community general store. As in many mining towns, the mercantile was the camp center of commerce, conversation, and fun, particularly on a Saturday payday. The storefront is wider than the interior, the typical Western "false front." The Santa Rita Mountains hover in the east background. Courtesy Arizona Historical Society.

THE BOSSES. Helvetia bosses, easily identifiable by their neckties, congregate in front of the Helvetia Mine office. The portrait shows the typical determined stare of men who must get the ore out to make their fortunes, then move out and do the same thing at the next good prospect. Courtesy Arizona Historical Society.

MEXICANS. Two Mexican men ride into town. Mexicans were native to the area long before the Gadsden Purchase. Mexicans and Mexican-Americans worked in the early Arizona mines, from pick and shovel work deep below the surface to the smelter. They lived as families, with their wives and children in many mining camps, and were paid in *boletos*. The Santa Ritas, referred to as a "heavy weight," tower in the background. Courtesy Arizona Historical Society.

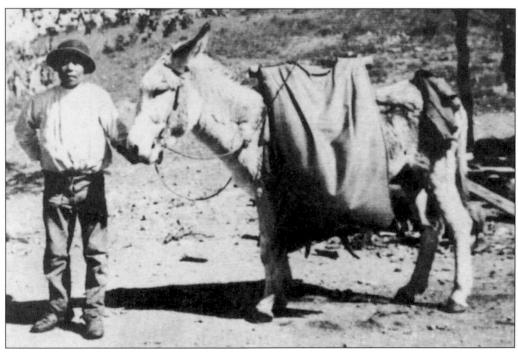

WATER DELIVERY. A young man, probably Hispanic or Papago, delivered water by burro-back to Helvetia miners. His goatskin bag had a spout at the bottom, a primitive spigot to pour out the precious fluid without wastage. His sources of supply may have been the Helvetia, Shamrod, Chavez, Zackendorf, or various unnamed local ephemeral springs. The animal's strength and sure-footedness made it an able worker for precipitous, rocky terrain. Courtesy Michael Kalt III.

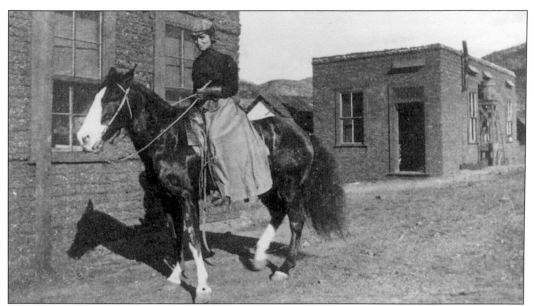

WOMAN ON HORSEBACK. About 1902, a Helvetia horsewoman rides past two brick buildings. The horse was the easiest and most convenient way to get around camp, although the donkey was the best way in and out. In 1902 the Helvetia Copper Company owned the land and the mines. Helvetia, easily reachable from Green Valley, is a private holding surrounded by the Coronado National Forest. Courtesy Arizona Historical Society.

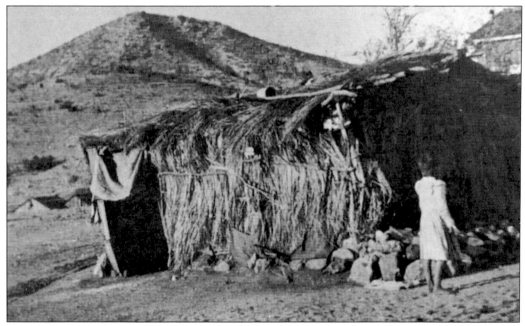

HOME. A woman looks at her Helvetia brush home. Occupying family homes in the 1900s in a mining camp, lost in the Santa Rita mountain wilderness, meant roughing it. The wife saw her husband only after a long, exhausting workday, had no water in her kitchen, and few utensils to prepare the meals. Wages were low and a salaried worker could only dream of a lucky strike for himself. Courtesy Michael Kalt III.

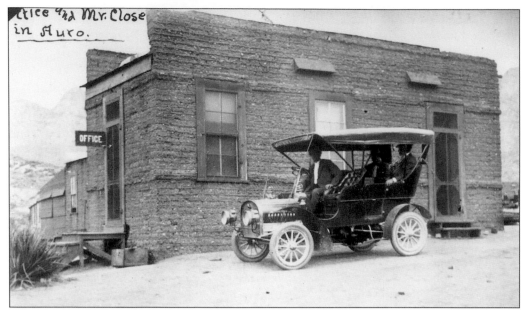

AUTOMOBILE. Mr. Close in his shiny, 1906 2-cylinder touring Rambler. Two passengers sit in the back. The road this car traveled was passable then; now it is classified as "unimproved." The adobe brick office was the nerve center of early Arizona mining, where miners met, talked, and received their cash or *boletos*. The assay office determined the percentage of copper in the ore. When the assay dropped too low, the mine was forced to economize or close, and the facilities were abandoned or leveled. Courtesy Arizona Historical Society and Antique Automobile Club of America.

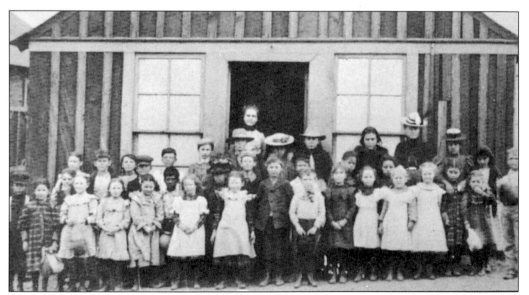

SCHOOL. Eulalia "Sister" Bourne is pictured here, among other teachers and pupils. School arrived early in Helvetia, but depended on world copper prices. When Helvetia Camp became a full-blown boomtown in 1903, a one-room schoolhouse was erected next to the general store. When the town busted in 1923, the Helvetia School District closed with its last 10 students. Elementary students were transferred to Sahuarita and the older grades to Tucson. Courtesy Michael Kalt III.

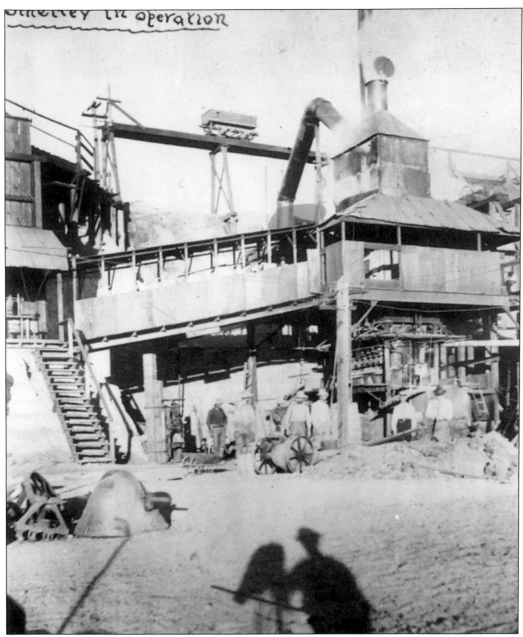

HELVETIA SMELTER. Ore-bearing rock entered the smelter and semi-concentrated ore came out. Men loaded it onto trucks and rail cars. Everything was hot, dusty, and dangerous and the days were long and strenuous. In 1865, Associate Justice Joseph Allyn of the Arizona Territory Supreme Court visited the mining districts in southern Arizona and reported to the Hartford, Connecticut *Evening Press,* that he did not enjoy his visit to the smelter. He described the glow of flames, the seething metal, half-naked laborers, ore entering one furnace and hot metal ladled out of another, and cooling bars smoking in the overheated atmosphere. Still, miners came from every state in the union, as well as many foreign countries, for the chance to work in Southern Arizona mines and smelters, earn a day's pay or strike it rich in the industry the Justice so disparaged. Courtesy Arizona Historical Society.

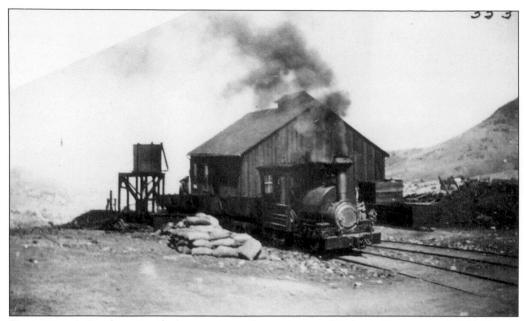

RAILROAD. A Southern Pacific locomotive pulls a train out of Helvetia Station, loaded with semi-concentrated copper ore to haul from the mine to the smelter. The early-day railroads, Twin Buttes, Tucson-Sahuarita, Tucson-Nogales, and Southern Pacific, laid track, built spurs, sidings, depots, and water tanks. Trains were indispensable to move heavy, bulky products, such as ore. Territorial Arizona supplied the semi-concentrates to Heyden, Arizona, and El Paso, Texas, which returned one day as wire, jewelry, and shiny new pennies. Courtesy Arizona Historical Society.

CHINESE. In 1899 a Chinese laundry opened in Helvetia. This man was on the mining frontier. His two grandchildren, an ocotillo, and barrel cacti encircle him. He wears a boater hat and turns his shirt out of his trousers for comfort. A low knoll in the background supports cholla cactus and other native desert vegetation. The Chinese arrived early in southern Arizona, first to lay railroad tracks and then to become merchants. Courtesy Arizona Historical Society.

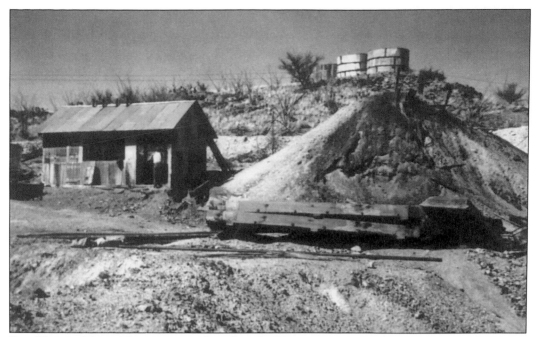

SAN XAVIER MINE. This is a view of small-scale Western mining, early 20th century. A mining shack, narrow-gauge railroad tracks to carry ore to the railroad, a large pile of slag anchored by a wooden barrier, and water tanks on the nearest hill were typical. Water was pumped from the mine shaft into the tanks and reused. Electricity lines pass by overhead. From 1897 to 1918 San Xavier produced lead, zinc, and silver ore. Courtesy Gael Chilson.

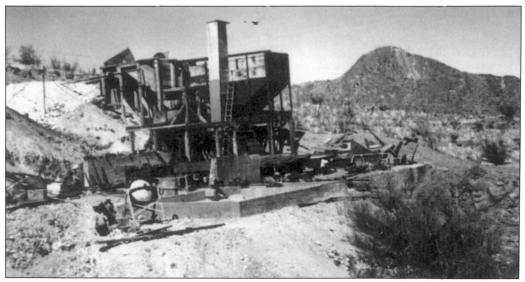

BERT'S MINE. Bert's Mine (actually the Whitcomb Mine) is named for Bert Walker, who pioneered the area about the time of the First World War. Left of the mill is a cement mixer, to build the foundation for the headframe. The mine produced lead and silver. Various mining enterprises, originally Olive Camp owned by the Brown's of Sahuarito, Helroc, and the Cactus Company, mined and milled, and closed at this location. The site in Dogtown, just off Mission Road. Courtesy Gael Chilson and Adelia Walker.

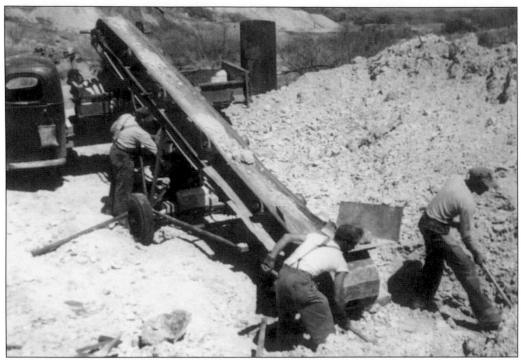

MEN AT WORK. Two men shovel and two others make sure the conveyor belt is working. Black slag tumbles out of the smelter. The men transfer it into the belt the hard way, and the belt dumps it into the waiting 1938–39 Dodge PowerWagon truck. This slag was used as tie ballast for the Southern Pacific Railroad, connecting the new copper mines south of Green Valley with the main line in Sahuarita. Courtesy Gael Chilson.

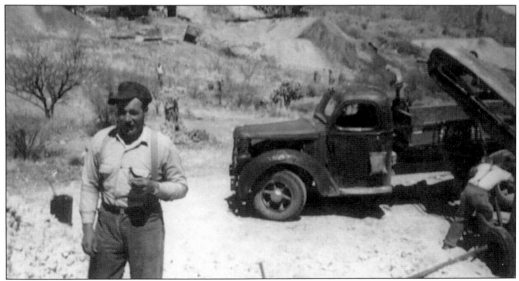

MAN OFF WORK. This is the other side of the process. This workingman, after a spell of hard labor on the conveyor belt, points his shovel into the ground for a well-deserved break. Behind him are a power shovel, mine shack, and a mill; to the right is the PowerWagon. Helmet Peak is in the background. Courtesy Gael Chilson.

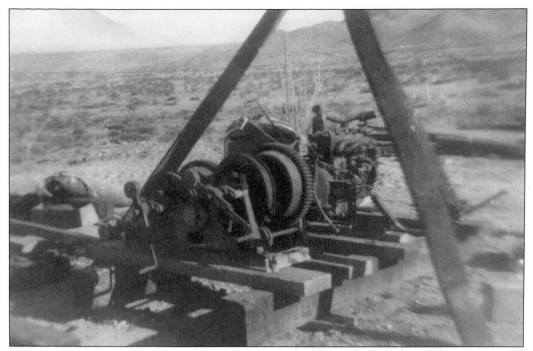

RELICS. Pictured are old gears at the hoist house in Bert's Mine, under an abandoned tripod. An engine supplied power to turn the gears, so men could get into and out of the mine. The gears rest on a solid wood foundation. Courtesy Gael Chilson.

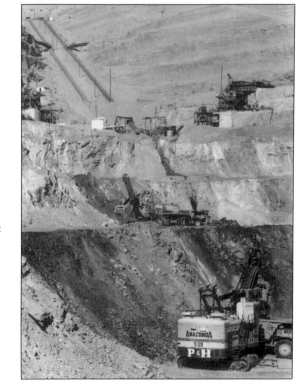

DOWN IN THE PIT. Pictured is a gigantic power shovel down on the mine floor. Anaconda, S 09, P&H, is electrically driven with a cable connection. In the background, one or two tiers up, copper-bearing rock is blasted, then loaded into the truck. When ASARCO purchased the Pima Mine Deep Pit, they dug next to Pima. Eventually the two pits merged underground. Courtesy Conrad Joyner-Green Valley Library.

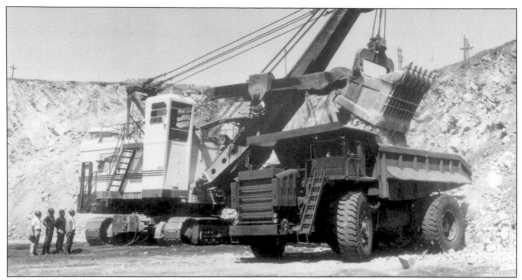

LOADER. The tractor loader, with a capacity of 15 cubic yards, loaded the 110-ton ore truck in three great scoops. The tires dwarf four men in the back. The ASARCO Mineral Discovery Center, on Pima Mine Road, has many local mining artifacts: a wooden headframe, pumps, engines, hoists, rail ore carts, and a small fleet of 240-ton trucks. Courtesy Conrad Joyner-Green Valley Library.

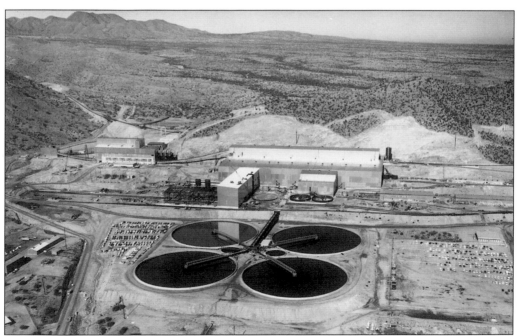

SIERRITA MINE. An aerial view of Duval Sierrita Mine and Mill shows above-ground facilities, June 1974. The four copper settling lagoons are filled with ore and water. After settling, a conveyor belt carries ore to the crusher, which reduces it to pea-size, crushed again in the ball mill, and floated. Ore goes to a small thickener, then the main thickener behind the lagoons is scraped off as "mud" and refined as copper. The residue is conveyed to the tailing piles, where it remains. Courtesy Conrad Joyner, Green Valley Library.

Nine

MOUNTAINS AND CANYONS

" . . . These high points of Arizona excite the imagination. It is not enough that they be sacred only to the Indians. . . . As a people we must recognize that there is a power that cannot be measured by our instruments." So says an anonymous early visitor to Arizona.

HELIOGRAPH. This is Heliographic Station on Mt. Wrightson (Baldy Peak), named after U.S. Army Captain Ewell (Old Baldy). The station was installed in 1886–87 and functioned until 1890. The military operator flashed dots and dashes in Morse code from the hinged mirror. Geronimo was said to be awe-struck by this "sun-mirror." This print, among others by Francis Beaugureau, who worked in Tubac and Tucson in the 1970s, was given away by Valley National Bank in Green Valley as a sales promotion. Courtesy Tubac Historical Society.

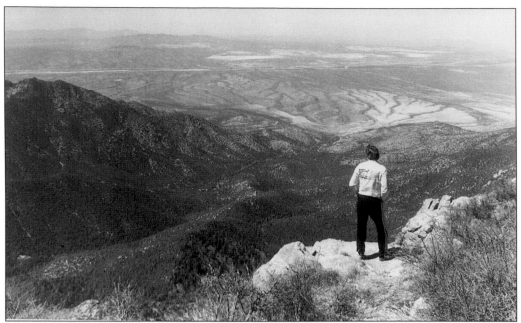

MOUNTAIN VIEW. The view from Mt. Wrightson, 9,453 feet, is spectacular. The climber gazes down at the dendritic pattern of the dry arroyos. Green Valley, which appears as a thin, distant strip along the uninhabited areas, is off in the distance. Further west are the Sierrita Mountains. Courtesy *Green Valley News & Sun*.

UPHAMS. In 1907, members of the extended Upham family enjoy a holiday picnic under the oaks along the banks of flowing Madera Canyon Stream. Stan Mansfield strums the guitar, while George Martin Jr., upraised arm, joins in the fun. The Uphams were inveterate travelers and photographers, on many subjects in southern Arizona. Their contributions to the Arizona Historical Society fill many folders and boxes. Courtesy Arizona Historical Society.

RAMBLER. In March 1907, this 1904 Rambler toured Madera Canyon. The driver, right, finds a resting place on the ground at the foot of Mt. Wrightson. His brother Charles Jeffrey survived the Titanic sinking, but later sold the company to Charles Nash, who continued it into recent times. Courtesy Arizona Historical Society and Santa Cruz Valley Car Nuts.

BABOQUIVARI PEAK. Baboquivari is an extinct volcano, where molten rock hardened into a great, striated, eroded cone. The word comes from the original Tohono O'odham *vau kivolik*, a narrow place between heaven and earth. Father Kino envisioned a tall ship balanced on a ridge. Americans call it "Babo," Mexicans, *el tambor*, the drum. This Tohono O'odham center of the world rises high over the Sonoran Desert floor, 56 miles and a world away from Green Valley. Credit J. Ross Browne, *Adventures in the Apache Country, A Tour Through Arizona and Sonora*, 1864.

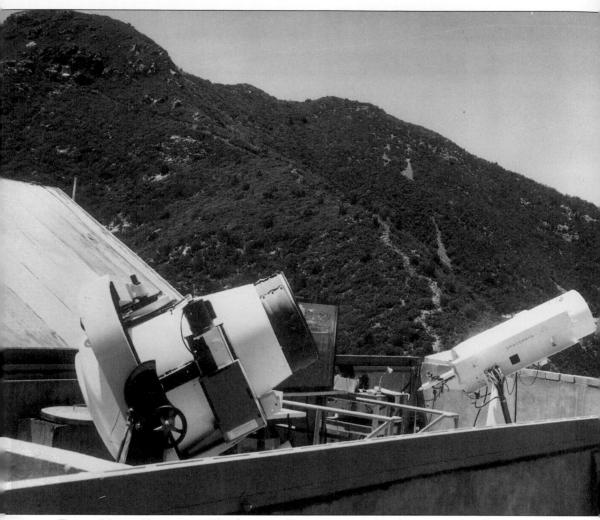

BAKER-NUNN TELESCOPE. The first installation atop Mt. Hopkins, now closed, was a satellite tracking station and laser gun dedicated in 1968. This telescope was part of a worldwide system of stations augmented by observation units. The mission was to detect satellites in the skies and send the data back home. The Smithsonian Institute in Washington DC considered building an astronomy observatory in the 1960s. Mt. Hopkins, in the Coronado National Forest of the Santa Rita Mountains, met the criteria of a good site; clear nights, high elevation, moderate weather, and low light pollution. Existing mining roads provided mountain-top accessibility. The Smithsonian selected the site for the Fred Lawrence Whipple Observatory in 1966, which is easily visible from Green Valley. Courtesy *Green Valley News & Sun.*

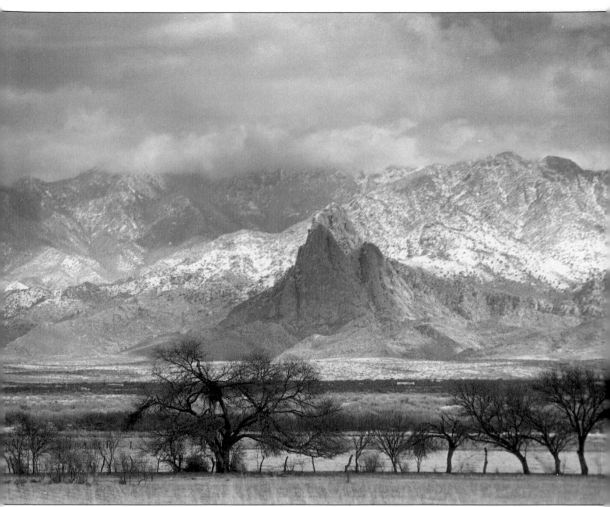

ELEPHANT HEAD. Elephant Head Butte was an important landmark for mule trains and early travelers between Mexico and Tucson. This sandstone promontory looms 5,640 feet above the 4,000-foot high desert, but is dwarfed by the immense Hopkins and Wrightson summits behind. With some imagination the butte may be seen to resemble a sad, tuskless pachyderm with a massive, bald, pointed dome and two very deep eyes. The trunk curls down to the right. Elephant Head lies in the Coronado National Forest, fringed by private and state land, accessible on dirt road by four-wheel drive from Madera Canyon. Early visitors explored Chino Canyon on the south face, to hike, camp, ride bicycles and horses, picnic, and watch birds. Ranchers graze the grassy meadows. Latter-day explorers may search for the "lost" Iron Door Mine, dating back to New Spain. Courtesy *Green Valley News & Sun.*

MADERA CANYON. Madera Canyon cannot have changed significantly in geologic times. In the 1780s, Spanish settlers in the Santa Cruz Valley knew the Santa Ritas as Sierra de La Madera, with reference to the wooded slopes. Timber was there for fuel and fencing, wild game for the hunting, and fruit and seeds for the gathering The U.S. Border Commission changed the name to the Santa Ritas, in an 1851–52 survey that preceded the Gadsden Purchase. Bill Kirkland, an early Anglo pioneer, established a lumber camp in Madera Canyon in the 1890s. He built White House Canyon Road from Continental, constructed a sawmill and sawpits for his State o' Maine axmen and hauled lumber by oxen team to Tucson. By the turn of the 20th century the tree stands were depleted. The Canyon is an outstanding birding area and renowned flyway of the Americas. The Green Valley/Madera Canyon Christmas Bird Count originated in 1900 when a group of conservationists protested the traditional bird shoot, and substituted bird counting for shooting. This photo was taken near Madera picnic area. Courtesy *Green Valley News & Sun.*

Ten

OLD NEIGHBORS

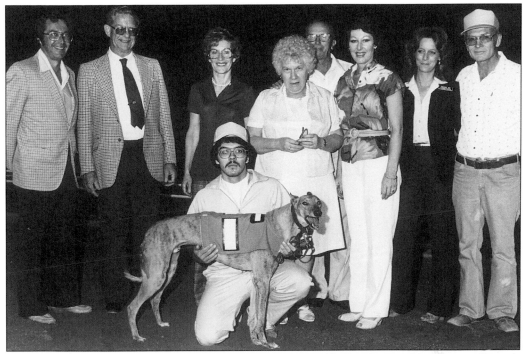

GREYHOUND RACING. Pictured, left to right, are Larry Caldrillo; George Clandaning, Branch Manager, First Federal; unidentified woman; Thena Myers, first manager, Green Valley Chamber of Commerce; and Suzanne Caldrillo. The Amado Greyhound Park flyer screamed:

"Another Green Valley Night Amado Greyhound Park, Sunday—August 30, 1964 6:30 P.M.

All Green Valley and Fairway Homes Residents have their Green Valley Season passes—if not—just stop by the Management Office or Green Valley News office—Shopping Plaza and pick them up—it's your pass to the dogs—and great fun too—this is Green Valley's way of going to the dogs—just 10 miles south on the Nogales Highway.

The Amado Greyhound Park Management plans many surprises and lots of Racing excitement—dog style—plus the Famous $3.00 per person dinner. Ask any one of your neighbors who was among the 100 odd Green Valley residents who made the Dog Races at Amado Greyhound Park in July—would like advance reservations—so we may have the special Green Valley section in the Club House.

So for a late Summer Highlight it's the Tracks for you—make up a party—but check your calendar now—firm it all up—and as Jackie Gleason would say— -and 'away we go.'" Courtesy *Green Valley News & Sun.*

AMADO GREYHOUND RACETRACK. This is the old Amado Greyhound Park. Today abandoned and defunct, the track has long since reverted to desert. The dogs are gone. Only a rutted overgrown field with sparse vegetation and a newer mobile home community remain. Philip Goorian collection.

COW PALACE. The Cow Palace bar and restaurant in Arivaca Junction, 20 minutes south of Green Valley, was a road stop, general store, bar, and dance hall. Under the honor system, the weary traveler helped himself to food and drink and left payment on the bar. This popular watering hole publishes its "Historama" on every menu: "…the Cow Palace was frequented by John Wayne, Joan Crawford, Gene Autry, and many other stars, whose famous faces now grace the bar." Philip Goorian collection.

THE LAKES. Visitors relaxed, ate, drank, and danced under salt cedar trees between the twin long-gone Kinsley Lakes. The Lakes flourished for 20 years, until deep pumping at Canoa lowered the water table. The Thomases of the McGee Ranch, related: "We rode the school bus to high school in Tucson. There were swim parties, down where the Cow Palace is today. That pool was cold." Today the lakes are dry holes in the ground and the cedars long gone. Courtesy Don Nussbaum.

GRANDMOTHER. This is a portrait of Grandmother Guadeloupe, a Yaqui Indian in the 1880s. She was a homemaker married to Ignacio Gomez, and died in 1980 at the age of 99. Today her descendants operate Café Wisdom in Tumacacori, where walls are lined with historical and baseball photographs. Courtesy Herbert Wisdom.

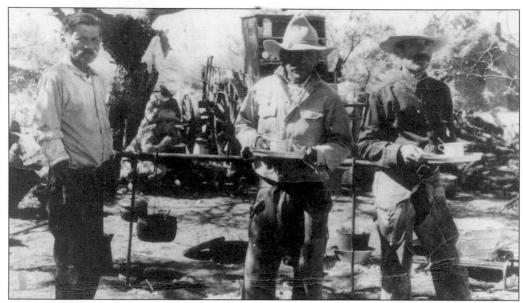

HOMESTEADING. Three Spanish-American homesteaders, left, Ignacio, Romeo, and Gilberto Gomez, uncles of the owner of Wisdom's Cafe, enjoy their outdoors lunch break. They settled before 1912 in the Amado area south of Green Valley in Arizona Territory. Later the State of Arizona claimed their cattle and their land. Mr. Wisdom recalls hearing that the Santa Cruz River, and all the *arroyos* ran full in their time. Courtesy Herbert Wisdom.

POSTCARD, TUBAC PRESIDIO. In 1775, the King of Spain commissioned Captain Juan Bautista de Anza to found a city in northern California. A pioneer party of 240 brave souls, emigrants, soldiers, priests, scouts and escorts, and wives, including 115 children, walked from the Tubac Presidio trailhead 1,200 miles through the Canoa Ranch to Alta, California and the Pacific Ocean. Anglo America did not arrive in this distant southwest frontier of New Spain for almost another century. The city Anza founded was San Francisco. Credit artist Bill Ahrendt, courtesy Tubac Historical Society.

TUBAC. " . . . When it (Tubac) became the headquarters of the Arizona Mining Company, it contained a mixed population of Americans, Germans, Mexican peons, and Indians. When the Federal troops were withdrawn to the Rio Grande in 1861, the Apaches came down from the mountains in large force, a Mexican party came in from Sonora for the same purpose of plunder. The inhabitants . . . abandoned the town and thus it has remained ever since, a melancholy spectacle of ruin and desolation." Now an art colony shines in "melancholy" Tubac. Credit J. Ross Browne, *Adventures in the Apache Country, A Tour Through Arizona and Sonora*, 1864.

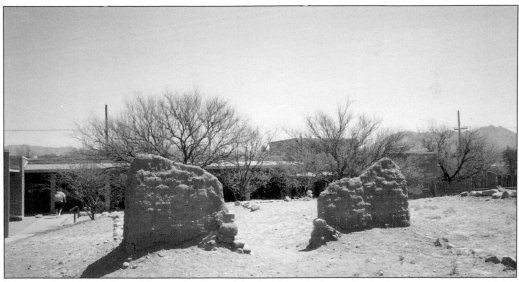

WALLS. The original Presidio walls were adobe brick and plaster built about 1910, on top of the old Presidio stone foundation. The protected and excavated 19th century floors show layers of ash, suggesting Apache depredation and/or fumigation. The *padres* made a vain effort to prevent European diseases from destroying the Pima Indians. Philip Goorian collection.

ARRASTRA. This *arrastra* at Tubac was a large millstone used to remove gold and silver from ore-bearing rock. Miners dumped ore into a trough and drove blind or blindfolded donkeys, mules, or horses in an endless circle, dragging rocks over the ore. As the ore broke into smaller pieces, miners added quicksilver, or mercury to form a slurry. Silver and quicksilver amalgamated and fell into a trough. The amalgam was vaporized in a smelter, to separate molten silver and by-product gold. Courtesy Tubac State Historic Park.

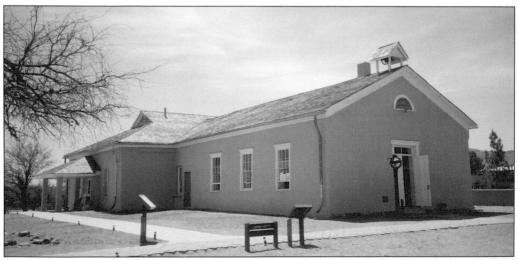

TUBAC SCHOOL. In 1876, Rancher Toribio de Otero granted land for a one-room schoolhouse, which continued in daily use until 1964. The schoolroom has hard wooden desks, inkwells, pen and pencil slots, underdesk storage, pictures of President Washington, and a copy of the American Constitution. A wood-burning stove overheated its immediate vicinity, leaving outlying pupils and teacher to freeze. The high ceiling provided an air space for warm months. The school district awarded male teachers free hours for courtship, but ladies faced dismissal if they married or engaged in other "unseemly behavior." Philip Goorian collection.

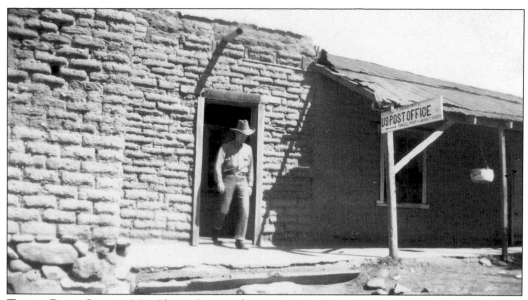

TUBAC POST OFFICE. Mr. Chary Ceran, about 1931, 4 Winds Ranch, leaves the Tubac Post Office. The double arrow sign proclaims "Post Office—Tubac Ariz." and "Parcel Post-Money Orders." "Tubac Ariz." is chalked on the upper beam. This adobe building in the center of town was built in 1904 and converted into the Nicholas Wilson art galley in 1940, acquired by artists Hans and Mary Valentine, and now their daughter Nancy, a writer. Courtesy Tubac Presidio State Historic Park.

NEWSPAPER. A statuesque printer's devil mans the *Weekly Arizonian*, founded March 3, 1859. This first English-language newspaper in Arizona, in four densely packed sheets, proclaimed: "If citizens would adopt the plan of shooting, on sight, all strange and suspicious Mexicans found lurking around their premises, it doubtless would have a salutary effect. . . . It would be well, before making another glass bead and cheap calico treaty with these Indians (Mescalero Apaches) to give them a handsome threshing (*sic*). . . . One great objective we will have in view will be to advocate the establishment of law and government in Arizona." Courtesy Tubac Presidio Historical Museum.

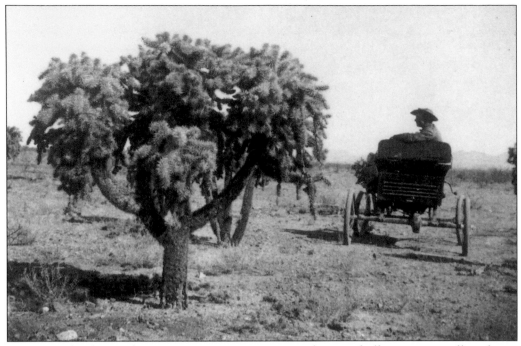

CHOLLA. The driver of a 1900–1902 Steamer stops to admire a cholla cactus, equally at home in town or desert. Almost pure stands of cholla flourish in the desert, and in Green Valley. The spines are very sharp. Courtesy Arizona Historical Society.

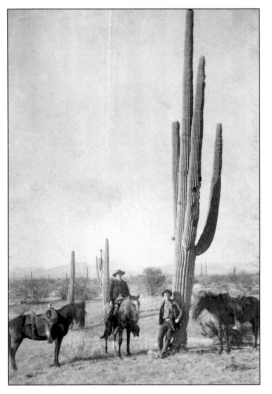

SAGUARO. These 25 to 30-foot giant saguaro specimens abounded in southern Arizona in the early 20th century. Cowboys and their horses stand against the "gigantic candle" which can attain heights of 50 feet or more, and live 200 years. The scarlet blossom is the Arizona State flower. The Tohono O'odham summarized flowering season best: "The tall mothers stand there, the tall mothers stand there, whitely they blossom, black the blossoms dry, red they ripen." Courtesy Arizona Historical Society.